Southampton
SOLENT
University

MOUNTBATTEN LIBRARY
Tel: 023 8031 9249

Please return this book no later than the date stamped.
Loans may usually be renewed - in person, by phone,
or via the web OPAC. Failure to renew or return on time
may result in an accumulation of penalty points.

Vancouver Art Gallery & The British Council

Body: New Art from the UK

Contents

Kathleen S. Bartels
Director,
Vancouver Art Gallery

It is with great pleasure that the Vancouver Art Gallery presents *Body: New Art from the UK*, organized in collaboration with the British Council. The exhibition is part of "UK Today: A New View," a year-long celebration of creative partnerships between Vancouver and the United Kingdom. The Vancouver Art Gallery has a proven commitment to featuring internationally acclaimed contemporary art and this exhibition not only extends that commitment but also strengthens our longstanding and fruitful relationship with the British Council.

Historically, Canadians have complex cultural links to the United Kingdom and the Vancouver Art Gallery has always acknowledged those links through the exhibition and discussion of art and culture. The Gallery's 1931 inaugural exhibition showcased its first art collection, which was largely British in origin or tradition; in 1951, the Gallery collaborated with the British Council on the major exhibition *21 Modern British Painters*; in 1953, *Five Contemporary British Painters* and in 1968, *New British Painting and Sculpture*. In 2002, major survey exhibitions were presented of works by UK artists Douglas Gordon and Gillian Wearing, while the Gallery's permanent collection includes major works of UK artists such as Wearing, Willie Doherty, Harold Chapman, Hamish Fulton, Anish Kapoor, Richard Hamilton and many others. *Body: New Art from the UK* is another stellar example of the keen interest and admiration that flourishes between Canadian and British artists and institutions.

On behalf of the Gallery, I extend our sincere thanks to the artists participating in this exhibition: Fiona Banner, Martin Boyce, Jake and Dinos Chapman, Tacita Dean, Tracey Emin, Douglas Gordon, Sarah Lucas, Cornelia Parker, Sam Taylor-Wood, Rebecca Warren, Gillian Wearing, Cathy Wilkes and Carey Young, whose contributions continue to challenge and inspire. Our appreciation also goes to the artists' dealers and the lenders to the exhibition: The British Council; Michael Black; Frith Street Gallery, London; Gagosian Gallery, Beverly Hills; Maureen Paley, London; The Modern Institute, Glasgow; Sadie Coles HQ, London; Jay Jopling/White Cube; London.

I want to thank Douglas Coupland for his insightful and humorous contribution to this catalogue and Julian Gosper for his elegant design. A very special thanks to Colin Ledwith, Curator with the British Council, and Bruce Grenville, Senior Curator of the Vancouver Art Gallery, for the realization of such a remarkable exhibition, and to the Gallery staff for their exceptional commitment. And lastly, thank you to the Killy Foundation for their continuing and unwavering support of the Vancouver Art Gallery.

Foreword

Peter Chenery,
Director,
British Council Canada

Brett Rogers,
Deputy Director,
Visual Arts,
British Council

In the framework of "UK Today—A New View," a year-long celebration throughout 2005 of creative partnerships between Vancouver and the United Kingdom, we are delighted to welcome this collaboration with the Vancouver Art Gallery. Initially conceived with Bruce Grenville in late 2003, the resulting exhibition *Body: New Art from the UK* amply fulfills our joint expectations that the selection should be undertaken entirely from a Canadian perspective, and that it would tour as widely as possible within Canada after its initial showing in Vancouver.

The mutual respect, admiration and ongoing dialogue between Canadian and British contemporary artists, which this exhibition exemplifies, has been the result of many decades of pioneering work by individual Canadian curators and gallery directors. There are too many to name individually. We are however principally and deeply indebted to Bruce Grenville for the intellectual rigour, imagination and sensitivity he has demonstrated in curating this invigorating exhibition. We also pay tribute to the strong support of Daina Augaitis, and thank the Vancouver Art Gallery Director Kathleen Bartels and all her staff most sincerely for the enthusiastic welcome accorded to the project by the Gallery.

Taking as its starting point specific bodies of work produced over the past decade, the exhibition attempts neither to foreground the particularities of geography nor generation but instead focuses attention on a shared interest by all fourteen artists in investigating "the body" and cultural geography. Given the parallel interest of Canadian artists and academics in related issues like the "somatic society" which have given prominence to the body in contemporary social theory, we anticipate that the exhibition will appeal to a very wide and diverse audience.

The exhibition could not have been organized without the cooperation of many individuals, amongst them numerous private lenders as well as the artists' galleries or representatives. We are most grateful to them for generously agreeing to the loan of works for an extended period. Colin Ledwith, Exhibition Curator and Dana Andrew, Exhibition Assistant, within the British Council's Visual Arts Department in London, have undertaken the curatorial coordination and project management with exemplary diligence, flair and energy. They have worked closely with the Department's technical workshop, transport agents and staff at the Vancouver Art Gallery on all aspects of the show. Finally but by no means least of all, we would like to acknowledge the cooperation and enthusiasm of the fourteen participating artists included in the show, without whose support it would have been impossible to realize the project.

Foreword

Body

There can be no doubt that one of the persistent themes that links art and artists across generations and over centuries is the subject of the body. In the past three decades, while the more traditional genres of still life, landscape or portraiture, have sustained an enduring presence, it is "the body" that has emerged as the dominant subject of contemporary artistic practice. This persistent interest in the body is in part a product of the successive waves of feminism and a growing consciousness of the significance of sexual difference. But equally important has been an articulation of the body that emerges from a heightened awareness of cultural difference and the history of colonialism that continues to resonate throughout the world. Today, the body is no longer simply accepted as a universal symbol of a human presence, but is acknowledged as a complex, highly coded, shifting subject that lives within representation.

The fourteen artists in this exhibition all take the body as the principal subject of their work. As a group they represent two generations of artists who have approached this subject in distinct, yet connected ways. Sarah Lucas, Tracey Emin, Gillian Wearing, Sam Taylor-Wood, Jake and Dinos Chapman and Cornelia Parker are often identified with the yBa (young British artists), a loosely knit group of artists that emerged in the 1990s and identified the body, and often their own bodies, as a powerful site of social rupture and dissent. Their aggressive, in-your-face attitude united the strategies of British youth culture, mass marketing and high art. A second generation emerged, almost simultaneously. They too acknowledged the primacy of the body as a subject in contemporary art, but chose to emphasize its social complexity and its multi-coded character. Fiona Banner, Carey Young, Douglas Gordon, Tacita Dean, Martin Boyce, Rebecca Warren and Cathy Wilkes are represented in the exhibition by works that speak of the body as a site of complex social interactions; interactions which sometimes mask the body's presence and sometimes open it up in ways that reveal its diverse movements through the world.

Seen from the distant shores of Canada the work of many of these British artists seems rooted in an arcane social system—obscurely defined by class, an indeterminate politics of location, and a contradictory system of moral codes; and yet we are intimately tied to that place through a shared language, political and judicial systems, and a history of colonial rule.

In presenting this exhibition we re-enact the actions of many of these artists, seizing that world as we understand it, then editing, reconfiguring and rendering it into an image. The result is an imperfect, but revealing insight into the world of another that bears an uncanny resemblance to our own.

Sarah Lucas stands as an archetypical artist of her generation. Her work is brutally frank, both in its self-assessment and in its criticism of a culture that sustains an untenable set of social relations. Her series of self portraits produced between 1990 and 1998 was released as a set of twelve images in 1999. As a group it frames a wide-ranging but relentless response to a misogynist culture that belittles, stereotypes and otherwise constrains women. But rather than enact an earnest feminist critique, Lucas adopts a wayward sense of pleasure in the "fuck-you" attitude that such a history of suppression can produce. Lucas' *Fighting Fire with Fire* is the art equivalent of a rock anthem for a generation that defines resistance as a viable form of cultural critique. Lucas' persona is intensely gendered, but the boundaries are blurred. Her masculine clothing and gestures seem incongruous within a constellation of feminine narratives that shape conventional notions of sex, moral conduct, pleasure and mortality. Lucas' *Bunny Gets Snookered #4*, is one of a series of sculptural works that utilize the same counter-narrative principles as the self portraits but whereas in the photographs the art historical references are oblique or muted, here the references are emphatic. The references to Hans Belmer's *poupe* or Man Ray's enigmatic objects become problematic when Lucas resurrects them for use within her surreal tableau. Bunny's sexuality is uncontrollably polymorphous and undirected. As in the self portraits, the signs are intentionally distorted and reconfigured so as to produce a point of resistance against which the viewer cannot rest.

Tracey Emin's *Something's Wrong*, shares a similar interest in the use of non-traditional materials, and more specifically, materials and techniques traditionally associated with women. Emin's use of appliqué and embroidery signals an intimacy that is undone when combined with her starkly personal imagery. The embroidered figure in the work—Emin—reclines, legs splayed, with objects—coins—flowing from her vagina. The words, "SOMETHINGS WRONG," are writ large across the top of the cloth, and visible through the translucent material, on the obverse side are the words, "Terribly Wrong." In a second work, *I've Got It All*, Emin offers an image of an enlarged Polaroid photograph, in which she sits, legs splayed and draws a huge pile of pound notes and coins to her crotch. Sex and money, sex and death, death and money, the connotations

Sarah Lucas
Fighting Fire with Fire
1996
Courtesy the Artist
and Sadie Coles HQ,
London

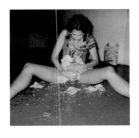

Tracey Emin
I've Got It All
2000
Courtesy the Artist and
Jay Jopling/White Cube,
London

ebb and flow across the works. We glimpse a fragment of an intensely personal narrative, one that is written from the body and on the body.

Through her work Gillian Wearing locates the body, and more often than not, her own body, in a series of liminal spaces and contexts. *Dancing in Peckham* is one of two early video works in the exhibition. Wearing's ecstatic public dance draws curious onlookers who seem to wonder at her actions, though there can't really be any confusion as to her intent, she is a young woman dancing to music in her head. We can't share the music, only the ecstasy of her actions. The presence of inappropriate bodies in public spaces is a common theme in Wearing's work. Or perhaps it is more accurate to say that they are bodies inappropriately placed in public spaces. In fact it is this distinction that is at the crux of Wearing's work and much of the work of her peers. In a hierarchical culture, defined by a strong moral code, dictums about appropriate and inappropriate behaviour are often focused on the body and the places and spaces in which they move. *Homage to a Woman...*, like *Dancing in Peckham*, comes from a similar impetus. Wearing recounts the story of a woman she saw on Walworth Road, a woman whose face was bandaged. She speaks of her with great admiration. She is "elated" and "seduced" by this "apparition." But when Wearing tries to recreate the event in homage to the woman, she encounters only unpleasant stares and a curiosity bordering on hostility.

Sam Taylor-Woods, *Five Revolutionary Seconds VI*, proffers a confounded sense of space by drawing the viewer along the surface of an image much in the same way that a film camera pans a scene. It is a movement that is optically familiar but one that is now estranged so that the viewer's body must move itself in order to recreate that panning motion. This sense of physical dislocation is further reiterated within the image where Taylor-Wood poses eight figures in autonomous configurations. Whether alone or in pairs, the figures seem isolated from each other and from their surroundings. Finally, the set or backdrop for this image is itself an anomalous space. What once was an industrial warehouse or factory, and later perhaps, an artist's studio, is now an elegant loft, a domestic space. The titular five revolutionary seconds is a five-second soundtrack that repeats again and again, the ambient noise of the space captured during its pictorial record, and is reinserted as yet another point of disjuncture. This sense of a constant bodily disjunction produced by the image is one that is at odds with the scene that is depicted. The luxury, the intimacy, and the wealth captured in this image, suggest a very different

Gillian Wearing
Dancing in Peckham
1994
Courtesy the Artist
and Maureen Paley,
London

world from that produced in the formal configuration of this work. There is an uneasy tension produced in this image that accurately captures a cultural moment where wealth and ethics seem to have embarked on irreparably divergent paths.

Jake and Dinos Chapman have consistently captured attention for their aggressively visceral artworks that never fail to provoke. *My Giant Colouring Book* speaks to two of the dominant themes in their work—the loss of innocence and the mutation of existing images and objects. The twenty-one etchings that comprise this work are drawn from the pages of a child's colouring book, but each page has been reconfigured so as to evoke a nightmarish or at least hallucinogenic tableau. A nightmarish clown, an eviscerated teddy bear, screeching monkeys and an exploding cottage are intertwined with Surrealist-inspired images that seem to have leaked from the unconscious mind of a child-colourer onto the pages of the book. Unlike an earlier Chapman brothers' appropriation of Goya's *Disaster's of War*, where the artists had clearly altered an original set of Goya's etchings, here in the colouring book the authorship and the alteration is not so clear. Where does the original colouring book end and where does the Chapman brothers' alteration begin? The Chapmans' interest in the mutant body, either intentionally altered or genetically aberrant, is a consistent theme in their work. For them the body is the locus of morality, the point from which morality is delivered and the site to which it is applied. The body's configuration is, quite simply, a moral measure of its context. For the Chapmans, it is clear that the boundaries and hierarchies that are traditionally used to inscribe the body are, in fact, a sham. Instead each body bears the signs of its moral and mortal circumstance.

Cornelia Parker is equally interested in reconfiguring the real in order to open it up to scrutiny. *Shared Fate (Oliver)* is a child's doll sliced in half by the same guillotine blade that beheaded Marie Antoinette (now in the collection of Madame Tussaud's London "Chamber of Horrors"). It is, to be sure, a rather horrifying object, but it should be noted that other objects that shared this same fate include a burned loaf of bread, a copy of *The Times* of London, a silk necktie, leather gloves and a deck of cards. The fate that is shared is not only one of horrific bodily mutilation, but also can be accurately described as a simple reconfiguration of the physical structure of an object. For Parker history appears to live somewhere inbetween these two points – between the infamous events of historical fact and the banal reality of physical being. Parker's photographs from Sigmund Freud's study, *Marks Made by Freud, Subconsciously* and *Feather from Freud's Pillow (from his Couch)*,

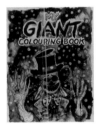

Jake and Dinos Chapman
My Giant Colouring Book
2004
Collection of the
British Council

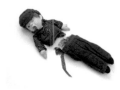

Cornelia Parker
Shared Fate (Oliver)
1998
Courtesy the Artist and
Frith Street Gallery,
London

follow a similar strategy. The marks made by Freud are nothing more, or less, than marks made on the surface of the chair where Freud sat in his study and the feather is a remnant of his famous couch. These object/images link the physical to the metaphysical, the everyday to the eternal, and the conscious to the unconscious.

If it is possible to draw a conceptual line between the artists noted above and those that follow, it would be a line that is drawn around their conception of the body and its potential for meanings within a social context. If the earlier group of artists looked to the gross, physical body and its configuration as locus of meaning, then the artists that follow may be said to have reacted and responded to that methodology by embedding the body into a much more densely configured set of social codes that trace its presence in the world.

Fiona Banner's *Spread 1*, is one of a series of works that find their source in a 1998 pornographic film, *Asswoman in Wonderland*. For this work Banner has transcribed the actions of the film in an extended description. The text is immediate and direct. Its flow is relentless. It bears no emotional quality and yet there is an intensity that is undeniable. This intensity is in part a product of the language and the subject matter, but is also a product of the pacing and rhythm of Banner's description, the rhythm of her body watching and transcribing. The text is printed on the panels in a fluorescent pink ink. It is laid out in a san serif typeface, entirely in caps, without paragraph breaks and fully justified left and right. The density of the surface makes it almost impossible to read as a continuous narrative. Instead the eye leaps from point to point, settling on individual words or short strings of words. Within this matrix of bodies—the actors', the artist's and the viewer's—a new body is configured, a body that is shaped and defined by language.

Carey Young's video *I am a Revolutionary*, is similarly determined by a focused link between language and the body. But that is where any comparison to Banner's work would rightly end. In this short video, Young is depicted working with a man who coaches her to craft the delivery of the phrase, "I am a revolutionary." He instructs her on cadence and emphasis, urging her to repeat again and again this phrase that, in its repetition, becomes entirely devoid of meaning. The coach is a professional, like Young, smartly dressed in contemporary business attire. His business is to teach her to produce a convincing delivery of that phrase, her business is to deliver it to a future audience with all the conviction that she can produce. But whatever their intent, it is clear that the results are a long way from convincing. Drawing on Marcel Duchamp's notion of

Carey Young
I am a Revolutionary
2001
Commissioned by Film & Video Umbrella in association with John Hansard Gallery, Southampton
Courtesy the Artist

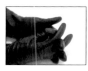

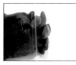

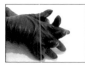

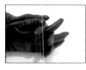

the artist as ready-made and Joseph Beuy's belief in the artist as performative presence whose actions create new social spaces, Young proffers a notion of the artist as a corporate body, framed by the language of business, branding and consumption.

Douglas Gordon's three recent "hand" videos are part of an ongoing series of works that present a pair of disembodied hands engaged in a series of actions. In this installation, *The Left Hand Doesn't Care What the Right Hand Isn't Doing* and *The Right Hand Doesn't Care What the Left Hand Isn't Doing* are juxtaposed with each other. In each, the hand in question shaves and then blackens the other. The image is startling in its simplicity but the sense of a directed and menacing presence is overwhelming. These works offer more than a simple morality tale written on the body. They link directly to the larger body of Gordon's work and beyond it to a world of artistic, literary and philosophical debate on the subject of good and evil. The third video in the group, *The Left Hand Can't See That the Right Hand is Blind*, extends the first two beyond the stark binarism of good and evil, into a space of ambiguity and doubt. What if the left hand couldn't see that the right hand was blind? What if, Gordon asks with a nod to Nietzsche, God is dead? Who will guide our moral judgments?

Tacita Dean's film *Mario Merz* is a meditation on the body and memory. In the film Dean offers a short portrait of the Italian sculptor, Mario Merz, made not long before his death. Merz, who is a reluctant sitter, is positioned in a garden under a tree and speaks about the landscape and the light. The camera studies his face and hands as if absorbing those features into the lens. Merz's voice is often inaudible, in part because of his own ambivalence for the interview and, one imagines, because of a necessity for rudimentary sound equipment. There is an overwhelming sense that this interview has happened on the spur of the moment, a coincidence of intent and opportunity. Significantly, the origins of the work are more complex and open it up to even further interrogation. Speaking of the work, Dean notes that her initial interest in filming Merz sprung from her recognition of an uncanny resemblance between Merz and her own father. She resolved to find a way to film Merz. The opportunity arose when works by Dean and Merz's were coincidently presented in a group exhibition in San Gimignano. Dean took that opportunity to approach Merz and secure an interview. But in the process of the interview and the editing of the film Dean realized that Merz, in fact, had little in common with her father. Desire circles the body, shifting and reconfiguring memory, capturing and eluding meaning.

The overt references in Martin Boyce's work are to modernist art and design, literature and music, public and private spaces, and to language. The physical body is largely absent, yet it is clear that the body, and specifically the body produced within the modernist ethos is located somewhere near the heart of his work. *Everything Goes Away In The End* is both an anthem and a dirge for the idealism of the modernist ethos. The use of Eames and Jacobsen furniture in the sculpture connotes the desire for democratic modes of production and consumption. Likewise the Calder-inspired design of the mobile and the abstract geometry of the paintings, *We Fade in the Sun and Shine in the Lamplight (This Place Fills Us)* and *Brushing Against Strange Weeds (Edges and No Edges)*, speak to the desire for a universal language that would unite an international community of producers and consumers. But the body starts to leak into the work in subtle and not-so-subtle ways interrupting the utopian impulse. The mask-like features of the chair components suggest the presence of a doppelganger—the return of the repressed body. So too, the worn components of the chair mark an erosion of those ideals by the continued imprint of the physical body. And the painting is physically faded—a pale and anemic Other to its unfaded twin—a condition that seems impossible to accommodate with the modernist narrative.

Rebecca Warren is a sculptor whose works are closely linked to the tradition of moulding and sculpting clay. Like most of Warren's work, the three sculptures in this exhibition take the body as their subject. Her interest in the body as a grotesque, deformed figure captured in the medium of clay has a long and venerable history and connotes the work of artists such as Rodin, Degas or Giacometti. But even within this peer group her sculptures are more profoundly distorted and disfigured than seems plausible. These figures sit at the very limits of comprehension. There is too, an awkwardness in the work, the figures are clumsy and ill-proportioned, and no effort is made to justify that condition. Even Warren's decision to use a self-firing clay that gives the appearance of an unfired clay adds an element of weakness to the work. And yet each of these works has a presence and focus that reaches beyond their scale. The bodies these sculptures portray are composed in a language that reaches across modernism, drawing from diverse and contradictory sources, but they are united by a belief that modernism's idealist impulse cannot provide us with access to the real. Instead we must look to the body—grotesque, awkward, disfigured and unformed— to provide that point of access.

All of Cathy Wilkes' sculptures have a spare and willful directness. The principle components of *Untitled*, 2001—the

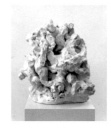

Rebecca Warren
Der Krieg II
2004
Private Collection
Courtesy the Artist
and Maureen Paley,
London

mattress, the tea tray, the carved wood and the paintings—are common to much of Wilkes' sculptural installations. They are, in a sense, the vocabulary from which she builds her narratives. There is a melancholy air to the work, one that emerges from the abject nature of the materials, but is also present in their configuration. The worn and rumpled mattress lies directly on the floor, the arrangement of the thin wooden slats implies the shape of a body, and the tray suggests a head pushed facedown to the floor. Two paintings, stained and discoloured, hang above on the wall. In this context the meaning of their text is ambiguous, but their effect is immediate. The reference to Dorothea Lange and the misfortunate souls who inhabit her photographs heightens and extends the tableau that is offered below, without providing any further insight into its meanings. Instead we are left to wonder, to self-consciously build a narrative that unravels even as we thread it together.

The work presented in this exhibition represents a diverse range of work by contemporary artists from the UK, and yet, there are so many others who could and should have joined in this dialogue. Entire histories and narratives have been left out in order to tell the story that is offered here. Yet, even within this fragment it is clear that these artists remain united by their shared conviction that the body, in its complexity and diversity, constitutes one the most compelling and critical subjects of our age.

Plates

ALL THE WAY SO YOU CAN SEE HIS BURSTING NOB. SHE STARTS TO LICK THE END, ALL OVER, LIKE SHE'S TRYING TO LICK SOMETHING OFF, LIKE A LOLLYPOP. SHE LICKS ALL THE WAY DOWN TO THE HEAT BALLS, IT GOES ON FOREVER, THEN SHE TAKES HIM IN HER MOUTH AGAIN. THE GIRL IN THE DRESS IS STILL IN THE DOORWAY. SHE'S FIXED ON THE GIRL, ON WHAT SHE'S DOING. YOU CAN SEE THE GIRL WITH THE AUBURN HAIR GOING DOWN ON HIM AND THE GIRL IN THE DRESS BEHIND, SHE'S PULLED UP THE DRESS AND YOU CAN JUST MAKE OUT THE HANDS ON THE CRUTCH, STROKING HER PUSSY THROUGH HER TIGHTS. THE GIRL ON THE BENCH IS LEANING OVER THE GUY NOW, BUT HE HASN'T MOVED AN INCH. HER CLUMSY WHITE SLING BACK SANDALS DANGLE OVER THE EDGE OF THE BENCH, RIGHT UP CLOSE HIS FEET LOOK HUGE. ALL YOU CAN SEE IS THE SOLES OFF HIS FEET AND HIS BALLS, LIKE A DEAD MAN. SHE GENTLY TAKES HIS COCK IN HER HAND AND STARTS RUBBING IT TO HER BREASTS, SIDE TO SIDE OVER HER NIPPLE. HER BREAST IS SMOOTH WITH SWEAT, HER NIPPLE'S GETTING HARD. SHE RUBS HIS NOB OVER HER FASTER AND THROWS HER HEAD BACK, HER LONG AUBURN TRESSES FOLLOW. HE LIFTS HIS HAND AND PUTS IT GENTLY ON HER BUTTOCK. THE GIRL IN THE DOORWAY PARTS HER FEET A LITTLE, MOVES AWKWARDLY AND TOUCHES HERSELF MORE, HARDER, LESS SELF CONSCIOUSLY. THE GIRL INFRONT TAKES HIS COCK IN HER MOUTH AGAIN HOLDING IT TIGHT, DOWN BY THE BALLS, PUSH-ING HIS NOB INBETWEEN HER LIPS. THEN SHE RUNS HER FINGER ALONG HIS SHAFT AND OVER THE END. HE'S VERY HARD HE LOOKS READY TO BURST. SHE STARES DOWN AT HIM, THEN FALLS DOWN ON HIM AGAIN. HER NECKLACE DANGLES DOWN ONTO HIS BALLS, HER HAIR STROKES HIS BELLY, SWEEPING ACROSS IT AS SHE SUCKS HIM IN AND OUT OF HER MOUTH. HER EYES ARE CLOSED AS SHE FALLS ONTO HIM, HE REACHES UP FOR HER HAIR, BUT CAN'T GET THERE SO HIS HAND HANGS IN MID AIR. THEN FALLS SLOWLY AND FINDS HER WAIST. SHE SUCKS HIM MADLY HER WILD HAIR FALLING ALL OVER HIM IN STRANDS. THEN SHE CLIMBS UP, CAN'T TELL WHAT SHE'S GOING TO DO. SHE'S STRADDLING HIM, ONE KNEE ON EITHER SIDE. SHE LEANS FORWARD. YOU CAN'T SEE HER CLEAN, HAIRLESS ARSEHOLE, DARK BETWEEN HER BROWN BUTTOCKS, HER SKIRT UP ROUND HER WAIST - THEN HIS COCK, SHINY AND HARD IN HER HAND AS SHE GLIDES IT INTO HER CUNT. YOU CAN SEE HER CUNT, ITS JUST WHERE HIS COCK IS GOING. SHE'S HOLDING THE SHAFT, GUIDING HIM SLOWLY, LETTING IT STRETCH HER MORE, THEN HE IS IN ALL THE WAY UP TO HIS BALLS. HIS ARMS COME UP HIS HANDS REST ON HER THIGHS ROCKING INTO HER, FORWARDS AND BACK. SHE PULLS HIM IN AND OUT OF HER CUNT. HIS HANDS COME UP TO HER RIBS FEELING HER MORE-STILL, PULLING HER NOW. HE PULLS HER AND SHE PULLS BACK, HIS COCK COMES IN AND OUT AND YOU SEE THE SHINY EDGE OF HER CUNT AND HER KNEES UP BY HIS HIPS ON EACH SIDE. SHE THROWS HER HEAD BACK. HER LIPS PART, SHE GROANS HER EYES CLOSE AND HER FACE GLISTENS WITH SWEAT. HE GRABS HER ARMS PULLING HER CLOSER TO HIS CHEST. SHE STARTS MOVING FASTER ON HIM, UP AND DOWN ONTO HIS HIPS, PULLING HIM OUT OF HER CUNT THEN BANGING DOWN ON HIM, REALLY BOUNCING ON HIM NOW, AND THROWING HER HEAD BACK, THEN FLOPPING FORWARDS. HER HAIR FALLING OVER HER FACE AND IN HER MOUTH. HE DOESN'T MAKE A SOUND BUT SHE MOANS AND PANTS. HER CUNT AND ARSE PRESS DOWN ONTO HIS BOLLOCKS, THE CRACK BETWEEN HER BUTTOCKS JUST A DARK LINE. HE PUSHES HER UP, SHE FALLS FOR-WARD A BIT AND PUTS ONE HAND ON HER PUSSY FOLLOWING HERSELF APART, HER CLEAN HAIRLESS ARSEHOLE LIKE A BLACK DOT IN BETWEEN HIS BALLS ALMOST SQUOSEN UP INTO HER CUNT. HER FINGERTIPS PRESS INTO HIS SMOOTH BUTTOCKS, HIS HAND COMES DOWN ONTO THEM. THEN YOU SEE HIS COCK EVEN CLOSER, STRETCHING HER OPEN, COMING OUT COVERED IN HER CUNT JUICE, ALL STUNG AND DARK. HE PULLS HER UP, HIS HANDS UNDER HER SHOULDERS. THEN SHE PULLS HER KNEES UP AND IS SITTING ON HIM. HE PULLS HER TOWARDS HIM, HER KNEES PRESS HER BREASTS, SHE STRETCHES AN ARM ROUND HIS NECK AND BOUNCES UP AND DOWN ON HIM, HER TITS SHINE. SHE PUSHES HIS THIGHS APART, MAKING HIS COCK HERS. THEN HE IS ON TOP, HIS BALLS FALLING AGAINST HER ARSEHOLE AS HE PUSHES HIS COCK INTO HER. HANDS ON HER LEGS PUSHING HER KNEES OPEN WITH ALL HIS WEIGHT AND PRESSING HIS COCK IN ALL THE WAY, HER ANKLES ARE UP ROUND HIS SHOULDERS SHE DANGLES THEM FREE IN THE AIR, THEN GRABS HIS ANKLES, HE IS SQUATTING BETWEEN HER LEGS. ONE FOOT EITHER SIDE OF HERS. SHE HOOKS HER FEET ROUND HIS NECK, AND PULLS HIM TOWARDS HER, NEARLY LOOS-ING HIS BALANCE. HE PUSHES HIS COCK SLOWLY IN AND OUT ALL THE WAY. HER CUNT PULSES WITH HIM, HE CLIMBS ONTO HIS KNEES AND RESTS HIS HANDS ON HER NECK TO PULL HIMSELF INTO HER, SHE GROANS. HE COMES ALL THE WAY OUT, THEN GUIDES HIMSELF INTO HER CUNT WITH HIS HAND, SHE PULLS HERSELF UP SO THAT SHE CAN SEE HIS COCK DISAPPEAR INTO HER. HER STOMACH IS SHINY WITH SWEAT. IT COLLECTS IN A PUDDLE BETWEEN HER BREASTS AND IN HER TUMMY BUTTON. HER CLIT IS PINK AND SWOLLEN. HIS DARK COCK INTO HER CUNT, EACH TIME IT COMES OUT SHINIER, WETTER. HIS HAND CLASPS THE BACK OF HER THIGH, PUSHING HER KNEE FURTHER BACK. SHE STRAINS FORWARDS TO SEE AGAIN, BUT CAN'T HOLD THERE LONG. HER FACE LOOKS PAINED, EXCITED, WHEN SHE SEES HIM PUSHING INTO HER. SHE LOOKS UP A LITTLE INTO HIS FACE, HER FACE WET AND FALLING BACK, SHE CLOSES HER EYES. HE PUSHES MORE WEIGHT ONTO THE BACK OF HER THIGHS, PUSHING THEM BACK, MAKING HER CUNT STRETCH OPEN, HE PUSHES INTO HER GENTLY, KNOWING WHERE TO PUSH. NOW SMOOTH IN AND OUT ALL THE WAY. THEN HE DOESN'T COME OUT ALL THE WAY, BUT PUSHES IN FASTER AN MORE FRANTIC. THEN IT COMES OUT ALL THE WAY, AS IF TO FIND HIMSELF AGAIN, AND HER CUNT AN' GOES BACK IN, FASTER, FASTER THEN HE PUSHES ON AND ... ING ALL THE WAY UP HIS SHAFT AND SHE MOANS. HE COMES OUT THE END OF HIS COCK LIKE IT MIGHT BURST RESTS ON HER PUSSY A SECOND, THEN FINDS ITS WAY BACK INTO ITS DARK HOLE. SWEAT STAINS HER CRUTCH, HER CLIT, SWOLLEN, BUT STRETCHED BECAUSE HE'S PUSHING IT SO FAR BACK. HIS COCK SHINY WITH HER CUNT JUICE. HE PULLS FORWARDS AND RESTS A HAND ON HER NECK, FEELING HER BREASTS. HE FINGERS HER EARLOBES SLIGHTLY AND KISSES HER. SHE PUCKERS HER LIPS TO KISS HIM BACK. AFTER THAT SHE IS MUCH QUIETER. SHE TURNS OVER ONTO HER KNEES, PUSHING HERSELF UP WITH HER HANDS ON THE BENCH. HE IS KNEELING BEHIND, PLAYING WITH HIS COCK. SHE LOOKS UP AND SEES THE GIRL IN THE DRESS THERE, SHE GLANCES BEHIND AT THE GUY AND SMILES THEN LIFTS A HAND TO BECKON THE GIRL OVER. SHE MOVES SLOWLY, SHYLY, OUT OF THE BLUE NEON LIGHT AND THE DOORWAY AND IS FACING THE GIRL WITH THE AUBURN HAIR. SHE TURNS AROUND, LETS THE OTHER GIRL TURN HER AROUND, LOOKING AT HER FACE, FEELING HER TINY WAIST AND UNDOES THE SASH AT THE BACK OF HER DRESS. THE DRESS FALLS DOWN TO HER WAIST. THE GIRL WITH THE AUBURN HAIR SITS ON THE EDGE OF THE BENCH, SHE IS BETWEEN HER KNEES. SHE LEANS FORWARDS AND TOUCHES ONE OF HER BREASTS AS IT FALLS FREE FROM HER DRESS. SHE DROPS HER HEAD AND HER LIPS FALL ON THE NIPPLE. SHE KISSES IT AND LICKS IT FROM SIDE TO SIDE SO YOU CAN SEE HER TONGUE AND THE NIPPLE GET BIGGER AND HARDER. SHE PLAYS IT WITH HER TONGUE, THEN ROLLS IT BETWEEN HER TEETH. THE GIRL STANDS THERE DOING NOTHING HERSELF- THEN SHE LETS HER HEAD FALL BACK AND HALF CLOSES HER EYES. THE GIRL WITH THE AUBURN HAIR TAKES HER OTHER BREAST IN HER HAND AND LIFTS IT UP TO HER MOUTH. SHE FLICKS SOME OF HER LONG BLOND HAIR GENTLY OVER HER SHOULDER SO THAT SHE CAN SEE HER NECK. SHE STROKES THE BACK OF HER HEAD AND GOES DOWN ON HER NIPPLE. THEN SHE TURNS AROUND AND SLOWLY CROUCHES DOWN BEHIND HER, FOLLOWING THE CURVE OF HER BACK AND BUTTOCKS WITH HER TONGUE. THE GIRL LIFTS HER FEET IN TURNS TO ALLOW HER TO PULL OFF HER WHITE TIGHTS. HER LEGS ARE SMOOTH AND BROWN UNDERNEATH. THE GIRL WRINKS HER WAY UP HER BACK. SHE IS SITTING ON THE END OF THE BENCH WITH HER FEET APART, BUT HER KNEES TOGETHER. THE SLOW GIRL STANDS THERE LOOKING INTO HER FACE, BUT WANTING TO LOOK INTO HER PUSSY. THE GIRL SITTING LETS HER KNEES FALL APART A BIT THEN PULLS THEM TOGETHER AGAIN. SHE BALANCES HER HIGH WHITE HEELS ON THE CORNER OF THE BENCH. THE OTHER GIRL LOOKS AWAY, LIKE SHE'S CHECKING NO ONE IS WATCHING, BUT HE IS THERE. THEN SHE FALLS DO...N ONTO HER KNEES THE GIRL LETS ONE FOOT DROP OFF THE EDGE, MAKING HER PUSSY OPEN, AND HALF PUSHES THE CROWN OF HER HEAL BETWEEN HER LEGS. SHE PUSHES HER PUSSY UP A BIT, SO THAT IT IS IN HER MOUTH. THE OTHER GIRL IS KNEELING BETWEEN HER KNEES, LIGHTLY SUCKING HER CLIT, LOOKING INTO HER FACE. WHILE SHE STROKES AND MESSES THE CROWN OF HER HAIR, HOLDING HER IN PLACE. BOTH HER FEET ARE UP ON THE EDGE OF THE BENCH NOW. SHE PULLS HER HEAD UP SO SHE CAN SEE HER DOWN THERE BETWEEN HER LEGS. SHE LOOKS FRIGHT WHEN SHE SEES HER AND SQUEEZES THE TOP OF HER HAIR AS IF TO ... ONTO SOMETHING, THEN STROKES IT FLAT, AND LETS HER HEAD DROP BACK. HER EYE-BROWS WRINKLE AND SHE CLOSES HER EYES. ... SHE CAN'T TAKE IT MUCH LONGER. UP CLOSE YOU SEE HER LICKING HER CLIT UP AND DOWN ALL THE WAY UP TO HER LITTLE BADGE ... UES AND BACK ALL THE WAY TO HER ARSE, THEN SHE STARTS PUTTING HER TONGUE IN HER CUNT, POSITIONING IT TRYING TO MAK... HOLE, SHE FLICKS HER TONGUE DELICATELY INSIDE, HER CLIT IS SWOLLEN AND PINK AND SHINY, A TRICKLE OF SWEAT ROLLS DOWN ... HER TUMMY BUTTON, SHE WORKS HER TONGUE UP AND DOWN AGAIN, ALL THE TIME LOOKING AT HER FACE, THEN BURYING HER ... IN HER MINGE SO YOU CAN'T EVEN SEE HER LIPS OR NOSE ANYMORE, THEN SHE PULLS BACK A BIT AND SUCKS THE SIDE OF HER CLIT, PULLING IT OUT SO ITS EVEN MORE SWOLLEN, SHE SUCKS THE OTHER SIDE, PULLING THE SKIN WITH HER LIPS. THE GIRL MOANS SOMETHING. THEN SHE STARTS LICKING HER CLIT, IN THE MIDDLE WITH VERY SHARP LITTLE STROKES. THE GIRL CLOSES HER EYES. SHE DROPS HER HAND ... HER SHOULDER AND GRABS THE GUYS ERECT COCK BEHIND HER SHOULDER SHE STARTS WANKING HIM WITHOUT EVEN LOOKING UP, WITHOUT OPENING HER EYES. HE'S STANDING JUST BEHIND HER. HIS COCK LOOKS HUGE AND

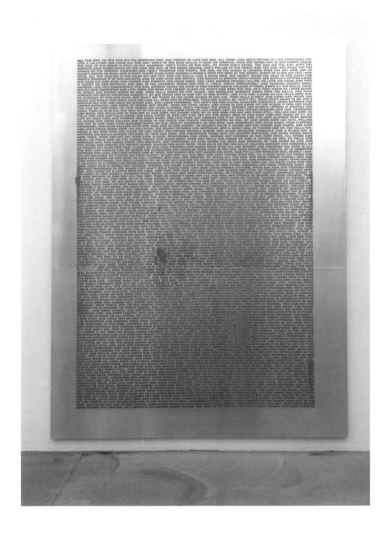

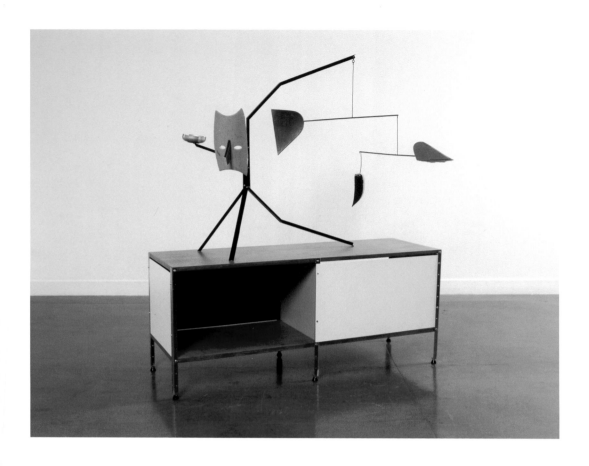

Martin Boyce **Everything Goes Away** Private Collection
In The End Courtesy the Artist and
2004 The Modern Institute,
Glasgow

Martin Boyce

**We Fade in the Sun
and Shine in the Lamplight
(This Place Fills Us)**
2004

Courtesy the Artist and
The Modern Institute,
Glasgow

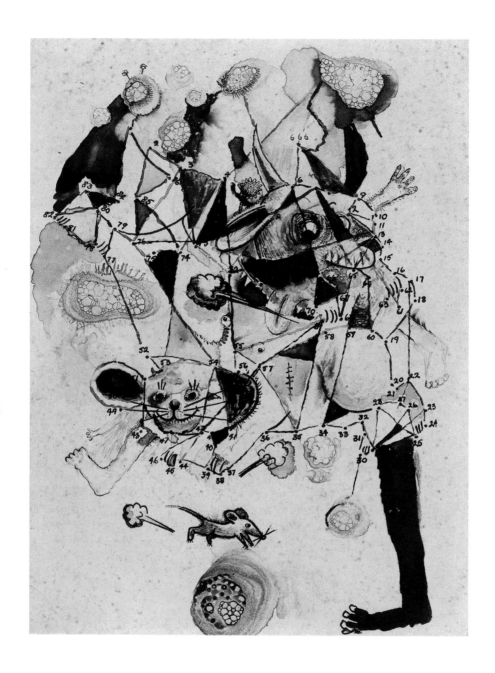

Jake and Dinos Chapman **My Giant Colouring Book** Collection of the British Council
2004

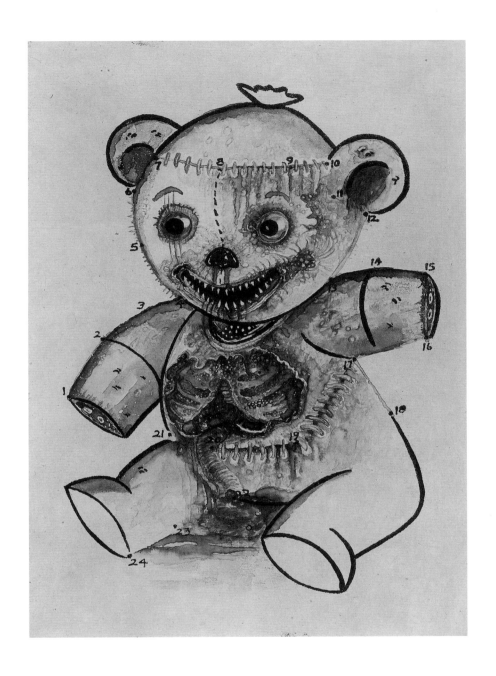

Jake and Dinos Chapman **My Giant Colouring Book** Collection of the British Council
2004

Tacita Dean

Mario Merz
2002

Courtesy the Artist and
Frith Street Gallery,
London

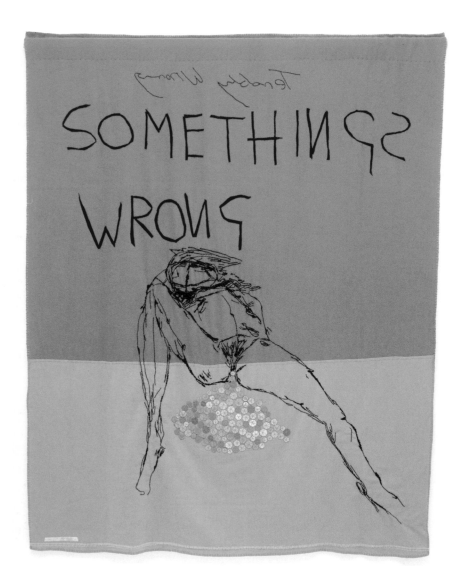

Tracey Emin

Something's Wrong
2002

Collection of the British Council

Tracey Emin

Top Spot
2004

Courtesy the Artist,
United Artists North America
and Jay Jopling/White Cube,
London

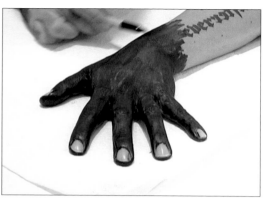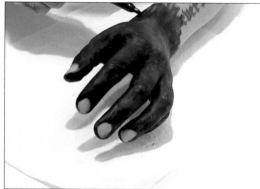

Douglas Gordon **The Left Hand Doesn't Care** Courtesy the Artist and
What the Right Hand Isn't Doing Gagosian Gallery, Beverly Hills
2004

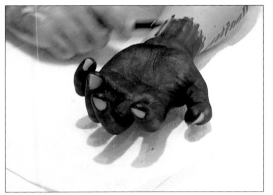
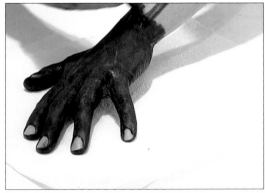

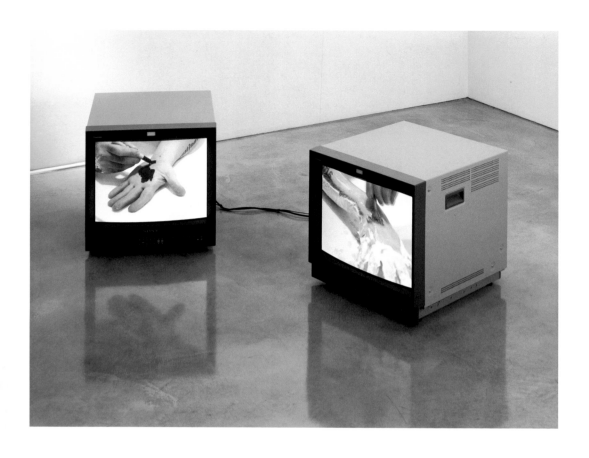

Douglas Gordon

**The Left Hand Doesn't Care
What the Right Hand Isn't Doing/
The Right Hand Doesn't Care
What the Left Hand Isn't Doing**
2004

Courtesy the Artist and
Gagosian Gallery, Beverly Hills

Sarah Lucas **Bunny Gets Snookered #4** Private Collection
1997 Courtesy the Artist and
Sadie Coles HQ, London

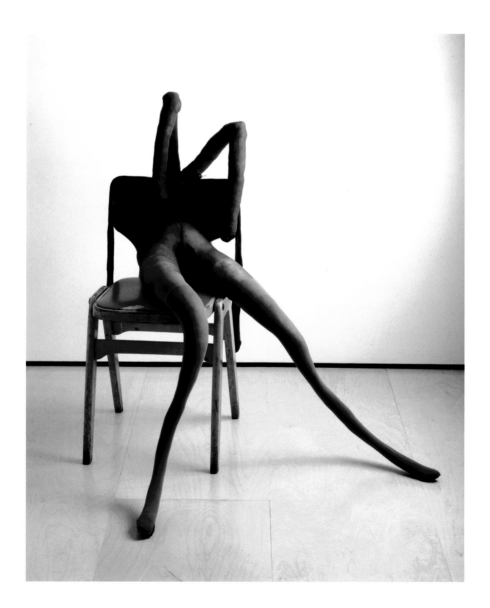

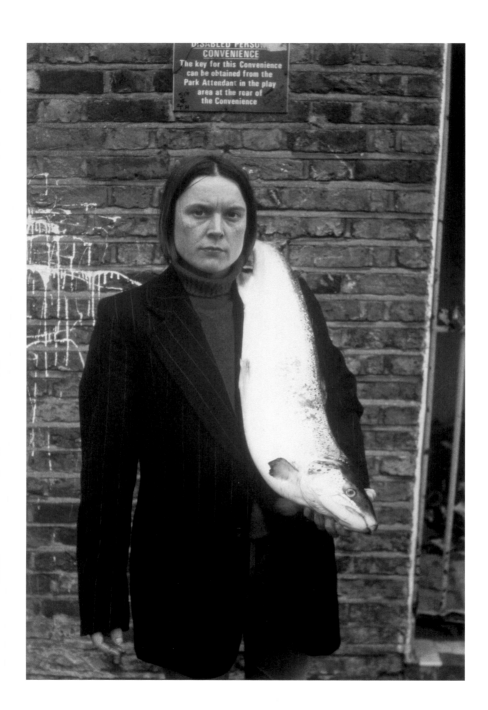

Sarah Lucas **Human Toilet II** Courtesy the Artist and
1996 Sadie Coles HQ, London

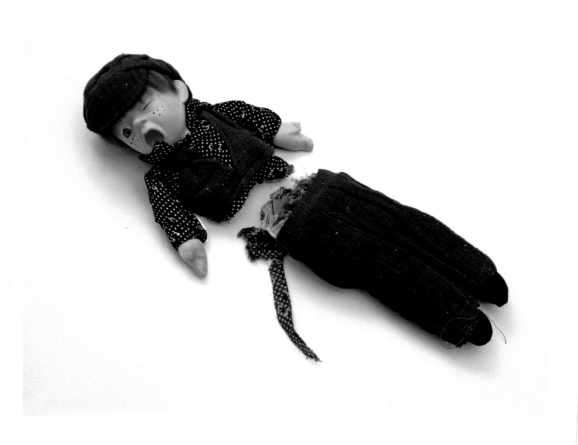

Cornelia Parker

**Marks made by Freud,
Subconsciously**
2000

Courtesy the Artist
and Frith Street Gallery,
London

Sam Taylor-Wood **Five Revolutionary Seconds VI** Collection of the British Council

1996

Five Revolutionary Seconds VI (detail)
1996

Collection of the British Council

Rebecca Warren

Head
2004

Private Collection
Courtesy the Artist and
Maureen Paley, London

Rebecca Warren

Saperstein
2004

Private Collection
Courtesy the Artist and
Maureen Paley, London

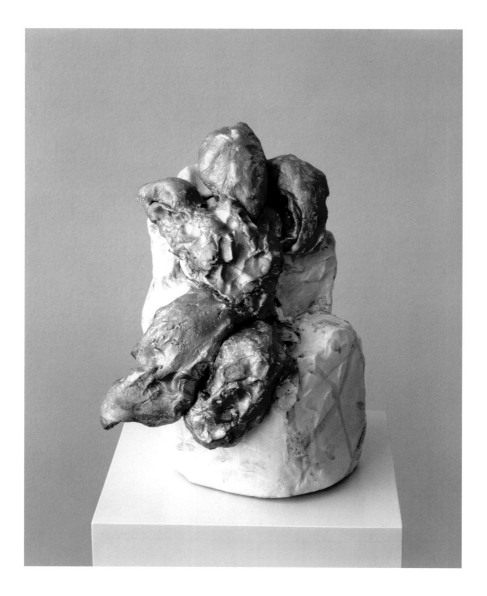

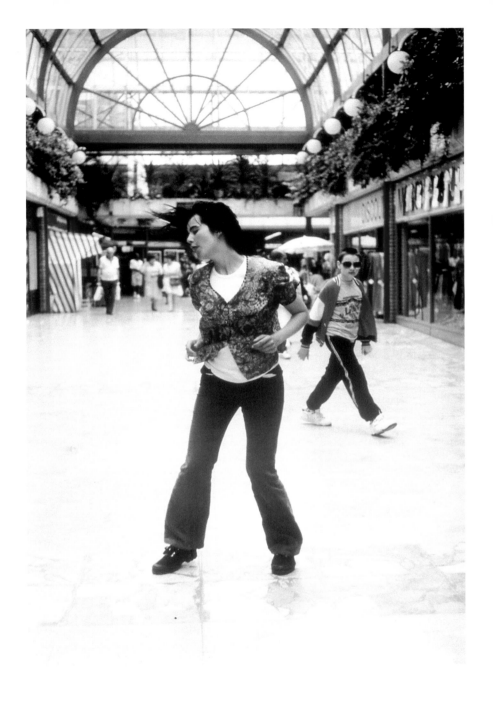

Gillian Wearing

Dancing in Peckham
1994

Courtesy the Artist and
Maureen Paley, London

Gillian Wearing

**Homage to the Woman
with the Bandaged face
who I saw Yesterday down
the Walworth Road
1995**

Courtesy the Artist and
Maureen Paley, London

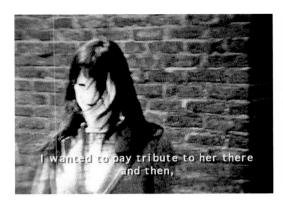

I wanted to pay tribute to her there and then,

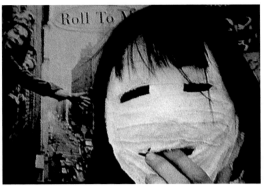

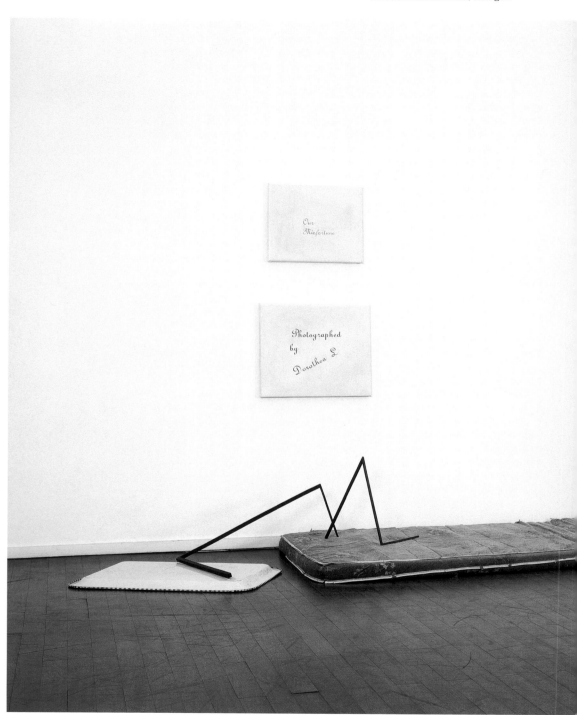

Carey Young

**I am a Revolutionary
(details)**
2001

Commissioned by Film & Video
Umbrella in association with
John Hansard Gallery, Southampton
Courtesy the Artist

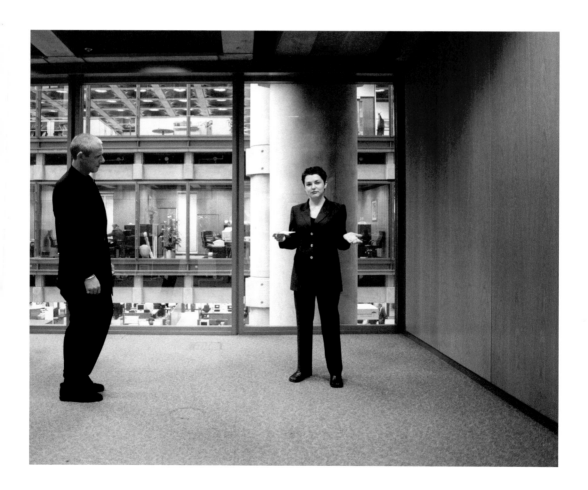

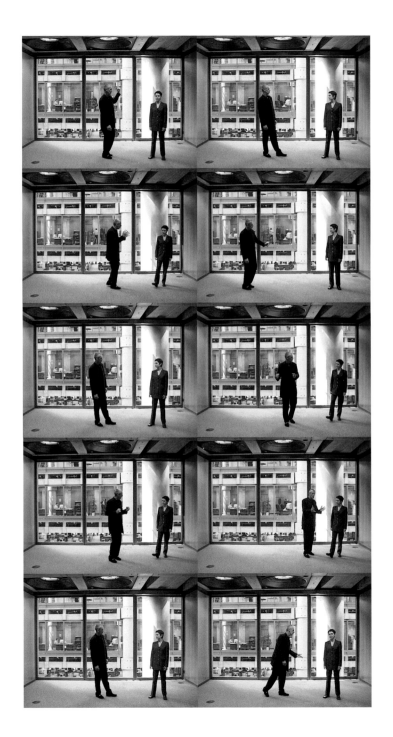

Disincarnation:
Shedding Your Meat

I remember reading art magazines in the late 1980s and early 1990s, and all of them moaned how unglamorous and unfocused and drab the art world had become. At this same time I began going to England regularly. A dominant memory of my earlier visits is of how hard it was to place phone calls in England—either within London or back to North America. I remember checking my hotel bill in a Glasgow hotel and being charged seventy-two pounds for a ten-minute call to Canada. I basically flipped out and there was a semi-ugly scene between myself and the manager who told me, "But Sir, your phone call used four hundred pips."

"What the hell is a pip?"

"A pip is a pip."

Insert a mental image of Basil Fawlty here.

In the end I got the phone charge reduced by half, but to this day, I still have no idea what a pip is. Another English phone glitch occurred in maybe 1995 when I found out the hard way that while both North American and English telecoms use push-button phone systems, North America's phones were touch-tone, whereas English phones weren't.

I remember trying to access my Canadian messages, but without a touch-tone, that couldn't happen. If we've learned anything in the early twenty first century, it's that not being able to access your phone or email messages is one of modern life's most discomfiting sensations.

So I asked the concierge what I could do, whereupon he told me of a magical device, a disc that, if you held it over the mouthpiece, you could use to generate touch-tone noises. I asked where I could find one.

"I have no idea, Sir."

"But this is a five-star hotel, and I can't possibly be the only North American to want to access their messages with a touch-tone system."

"Possibly."

"So don't you think it might be a desirable service to provide guests with this kind of device?"

Stony silence.

"And you really don't know where I can find one?"

More stony silence.

In the end I bought a touch-tone device under-the-table from a concierge at the Madrid Four Seasons. This got me

through the next three years or so of European trips.

And then...

And then I went to London one year—1998? And suddenly every English citizen had both a cell phone, a high-speed internet account and it was like the 90s had never existed— and suddenly I felt like an information hillbilly compared to the Brits. They'd technologically skipped decades of North American-style telecom and computing infrastructure.

What I also began noticing at this time was that people in the audiences at book readings had their cell phones ringing in the middle of events. From the stage or podium they sounded like chirping birds, which was kind of sweet—but then I began researching the Columbine shootings for a book I was doing, and an odd link occurred. I read this passage that described the scene in the Columbine cafeteria. While the shootings hadn't occurred there, a propane canister bomb placed there by the two young gunmen exploded, melting chairs and scorching the books and lunches surrounding it. Because there were bombs placed throughout the school, the Littleton, Colorado police and the ATF couldn't simply rush into the school. The building had to be combed foot-by-foot, room-by-room to ensure no further explosions. While they were doing their sweep, the fire alarms had been ringing non-stop because agents hadn't yet accessed the main office. The following paragraph comes from the *Denver Rocky Mountain News*:

> Marcus Motte of the Federal Bureau of Alcohol, Tobacco and Firearms ... was peering into the flooded cafeteria, looking at hundreds of backpacks left behind 11 hours earlier by panicked students. Some floated in the water covering the floor. Others sat on top of tables. The instant the fire alarm went dead, Motte heard a strange, almost surreal sound welling up faintly from inside, like birds chirping. Across the cafeteria, telephone pagers in the abandoned backpacks were going off, unanswered calls from desperate parents. Where are you? Please, please call home.

A few years later in October of 1999 there was a train crash in London's Paddington Station. Emergency workers removing the dead and injured also recalled the same wrenching observation, that of musical ring tones serenading the dead from within jackets and purses and briefcases.

I considered these two tragedies and from both Columbine and Paddington I began to feel as if human beings had developed some new form of spiritual disembodiment, that during these two ghastly historical apertures, with the addition of mobile phone technology, we were able to separate the spirit from the body in an almost scientific manner.

Because of this observation, at English book readings I began asking audience members to take out their cell phones and make them ring like crazy while the house lights were dimmed—all there was was darkness and these trilling, bleeping and rather pretty impromptu sonatas which went on for one minute. Audiences would initially giggle, but after fifteen seconds the giggling stopped; forty-five seconds later when the house lights were raised, we could all distinctly feel the presence of lost dead souls evaporating from the room like a whiff of perfume. We had all briefly left our own bodies and the effect was chilling.

But why discuss all this? What have we learned? I think we've learned that England—and most of Europe—underwent massive structural changes in the way in which they ingested their daily communications. Whereas North American shifts had been more gradual across a two-decade span from 1970 to 1990—cable and satellite TV networks and the implementation of modems—England's information shifts in the 1990s were more akin to being blasted by an information fire hose; it was cathartic, massive and brash. And two things became all too clear across that decade. First, there had arisen a new and undeniable menu of sensations and relationships in English culture, be it person-to-person relationships, or an individual's relationship to themselves. And second, in the 1990s there emerged a new sort of art that addressed these new relationships. This is, of course, the yBa movement. It was bold and sexy and drenched in death and fame and politics. It wasn't prescriptive—it had no long-term moral agenda—it was reportage. You could slam it, trash it, consume it, love it, discredit it, but whatever you did, you still knew that it was going to be the work that defined the era—not the stuff that came out of New York or anywhere else, something that has greatly angered New York.

Now in 2005 the yBa movement is over, passé, whatever. The dust has settled and we're beginning to see what's going to stand the test of time, and what's going to be tomorrow's doorstop. What remains is much of the work in this show. Seemingly austere, it reflects a culture inundated with a new range of sensations—a culture in which the individual has become porous—an information filter bombarded with constant streams of data, entertainment, spam and just about anything that can be zapped and downloaded and broadcasted. To view Gillian Wearing's *Dancing in Peckham* is to see a body desperately trying to shed itself of itself, to disincarnate, a body so enervated and overstimulated that corporeal existence has become almost untenable. It seems to be saying, *Just let me ditch my body for a little while. Not too long, just enough so that I can take a break.*

But of course the break is never going to come. In a strange way, a sixteenth-century depiction of the Annunciation, say, actually has much in common with *Dancing in Peckham* than one might first assume. Both depict the human soul at a moment of mind/soul/body transformation. Both depict a soul in need of some sort of transcendent intervention to remove them from the daily corporeal bother of life.

Tracey Emin's piece, *I've Got it All*, with coins seemingly discharging from her vagina reminds me of something I used to say in the 1990s. Whenever I entered a really good store full of things I was powerless not to buy I said, "Wow. I can already feel the money leaving my body." The 1990s in England were about not just money but *cash* and *shopping*—tons of it, all of it rewriting the country's old reputation as boring and puritanical. Not coincidentally, a publishing phenomenon arose in the 1990s in England, the S&F novel—shopping and fucking. Emin's work addresses the notion of affluence and social disengagement in a way that just barely manages to shock, but still does so in the end.

Martin Boyce's work, particularly *Everything Goes Away In The End*, also addresses the newly emerging relationships between the individual and consumption. *Everything Goes Away In The End*, in a way, depicts the Elephant's Graveyard of shopping; it acts as a sort of bleached out skeleton of *Wallpaper** magazine or a menswear sale at Harvey Nichols.

I could go on, but the gist of the show is seemingly about the mind/body relationship, one of art's eternal themes.

So yes, it is now seemingly okay to trash the 1990s and yBa. New York seems to be behind the wheel once more. But the yBa party was wild, with much stupid behavior and frivolous dancing, but what it got right it got very right. Let's face it: the manner in which minds and bodies relate to each other is fluid and ever changing. Art chronicles this relationship on an ongoing basis, and every time art gets it right, it comes as a slap in the face when you realize that what you expected and what you got rarely have much in common. Nobody expected the work that appears in this show, which is precisely why it remains after the champagne flutes and cigarette butts have been swept away.

Colin Ledwith

Fiona Banner
Born 1966

Born in Merseyside, Banner studied at Kingston Polytechnic, 1986–1989 before gaining her Masters at Goldsmith's College, University of London, 1991–1993. She is represented in various international public and private collections including Metropolitan Museum of Art, New York; Philadelphia Museum; The Arts Council of England; The British Council and Tate Gallery, London. Banner was nominated for the Turner Prize at Tate Britain, London in 2002. Fiona Banner lives and works in London.

Since her first notable solo exhibition *Pushing Back the Envelope* at City Racing, London in 1994, Banner has exhibited her work and commissions consistently in influential international venues including: *Viewing Room*, Luhring Augustine, New York, 1995; *Love Double*, Galerie Barbara Thumm, Berlin and Art Now, Tate Gallery, London, both 1998; *Don't Look Back*, Brooke Alexander, New York, 1999; *Soixante-Neuf*, Charles H. Scott Gallery, Emily Carr Institute of Art, Vancouver, 2000; Rainbow 24/7, Hayward Gallery, London, 2001; *Your Plinth is my Lap*, Neuer Aachener Kunstverein, Aachen, 2002 and *All the World's Fighter Jets*, Cubitt Gallery, London 2005.

Group exhibitions include: *New Contemporaries*, Camden Arts Centre, London and tour, 1994; General Release: *Young British Artists*, Scuola di San Pasquale, Venice and *Perfect Speed*, USF Contemporary Art Museum, Tampa, Florida, both 1995; *Spellbound: Art and Film*, Hayward Gallery, London, 1996; *An Exhibition of Art from Britain*, Museum of Contemporary Art, Sydney and Urban Legends, Staatliche Kunsthalle Baden-Baden, both 1997; *The Tarantino Syndrome*, Künstlerhaus Bethanien, Berlin and *Super Freaks—Post Pop and the New Generation: Part 1*, Greene Naftali, New York, both 1998; *Cinema, Cinema*, Van Abbe Museum, Eindhoven, 1999; *Customized: Hot Rods, Low Riders and American Car Culture*, ICA Boston, 2001; *Remix: Contemporary Art and Pop*, Tate Liverpool, 2002; *ATTACK— Art and War in Times of Media*, Kunsthalle Wien, Vienna, 2003 and *The Sky's the Limit*, Kunstverein Langenhagen, Hanover in 2004.

Banner is fascinated by the near impossibility of containing actions and the passing of time within a prescribed form. These ongoing concerns pervade perhaps Banner's best known series of work often referred to as "wordscapes" or "still films," blow-by-blow accounts of the sequence of events in highly specific feature films, hand written in her own words as the action passes on the screen.

These unpunctuated, single blocks of emotionless handwritten text, often in the same shape and size as a cinema screen, conflate the gender themes and power structures in films as diverse as *Top Gun*, *Apocalypse Now* and varied pornographic movies, removing hierarchies and enabling the narratives to exist in the same space, a process which Banner alludes to in her comment on the content of the pornography she has used: "immensely boring, but tremendously fascinating at the same time." Underpinning Banner's art is an interest in language as communication and the transference of language and meaning into a purely visual register.

Martin Boyce
Born 1967

Boyce was born in Glasgow, where he currently lives and works. He attended Glasgow School of Art 1986–1990, and

also completed his Masters at Glasgow School of Art 1995–1997. He was nominated for the first Beck's Futures Prize, ICA, London, in 2000.

Boyce creates spatial compositions which plunder vocabulary of twentieth-century art and design to form a unique visual language. The motifs and materials of urban modernism are incorporated into his practice, iconic design objects such as Charles Eames modular units or Arne Jacobsen chairs are altered and reconfigured into referents to their own lineage and aspiration.

Geometric wall paintings, text and occasionally sound are often combined with commonplace utilitarian materials; fluorescent strip-lighting used to create schematic neon trees in a vision of the dark menace of an urban park, conceived as a safe area for enjoyment, or the restaging of a mise-en-scéne office foyer composed of ubiquitous elements. Boyce explores a cultural world that incorporates functionality, though rendered dysfunctional, and reclaims a sense of hope and possibility in the process. He provokes his audience into an engagement with an art in which recent cultural references are absorbed and represented, offering an alternative version of their evolution.

Boyce held his first significant solo exhibition *When Now is Night* at the Fruitmarket Gallery, Edinburgh in 1996. He has exhibited widely since, further solo exhibitions including: Jerwood Gallery, London and *Fear View*, Johnen & Schottle, Cologne, both 2000; *For 1959 Capital Avenue*, Museum für Moderne Kunst, Frankfurt and *Our love is like the flowers, the rain, the sea and the hours*, Tramway, Glasgow, both 2002; Contemporary Art

Gallery, Vancouver and *Undead Dreams*, Roma Roma Roma, Rome, both 2003 and *Brushing Against Strange Weeds*, The Modern Institute, Glasgow, 2004.

Selected group exhibitions: *Life/Live*, Musée d'Art Moderne de la Ville de Paris, 1996; *Material Culture*, Hayward Gallery, London, 1997; *The British Art Show 5*, The Scottish National Gallery of Modern Art and tour, 2000; *Greyscale CMYK*, Tramway, Glasgow and *My Head is on Fire but my Heart is Full of Love*, Charlottenborg Museum, Copenhagen, both 2002; *Sodium Dreams*, Bard College, New York and *Still Life*, Museo de Arte Carrillo Gil, Mexico City, both 2003; *Formalismus Moderne Kunst Heute*, Kunstverein Hamburg and *Sodium & Asphalt*, Museo Tamayo Arte Contemporaneo, Mexico City, both 2004; *What's New Pussycat?*, Museum für Moderne Kunst, Frankfurt and *Die gute Form*, Galerie Mehdi Chouakri, Berlin, both 2005.

Jake and Dinos Chapman
Born 1966 and 1962

Dinos Chapman was born in London and Jake Chapman was born in Cheltenham, UK. Dinos gained his Bachelor of Arts at Ravensbourne College of Art from 1981–1984, Jake at North East London Polytechnic from 1988–1990. Both attended the MA Fine Art course at the Royal College of Art, London from 1990–1992. They began working as a collaborative team soon after graduating and were nominated for the Turner Prize, Tate Britain, London in 2003. Jake and Dinos Chapman live and work in London.

The Chapman bothers first received critical acclaim whilst still on their MA course in 1991 for a diorama sculpture created from remodelled plastic hobbyist figurine kits enacting scenes taken

directly from Goya's disturbing etching series *The Disasters of War*. Later, the Chapmans took a single image from the series and meticulously transformed it into a life-size tableau featuring altered fibreglass mannequins. Called *Great Deeds Against the Dead*, the piece depicted three castrated and mutilated soldiers tied to a tree. The appropriation of Goya's dark imagery, fused with the unnerving human scale of the work creates an experience of conflicting emotions; horror and beauty, perversity and black humour.

For their solo exhibition at ICA London in 1996, the Chapman's continued to employ life-size mannequins, this time in an exploration of innocence and moral boundaries. The mutant child figurines for which the artists have become renowned are the extreme manifestations of these ideas. The installation *Tragic Anatomies* comprised an entire "Garden of Eden" populated by these disturbing figures, naked with genitalia in place of facial features, their only addition being a pair of fashionable trainers worn by each.

Arguably their most ambitious work, no longer in existence, was a single multi-vitrine sculpture entitled *Hell*. An epic table-top tableau, it invoked a world devoid of moral structure. The piece combined historical fact with religious and mythic narrative. It featured over 30,000 mutated plastic figurines in Nazi uniform enacting small scenes of inhuman depravity, the vitrines themselves forming the shape of a huge swastika when viewed from above.

The Chapman bothers have exhibited extensively since their first solo exhibition *We Are Artists* at Hales Gallery, London in 1992. Further solo exhibitions include: Gagosian Gallery, New York and *Chapmanworld*, Grazer Kunstverein, Graz, both 1997; White Cube, London, 1999; Kunst

Werke, Berlin, 2000; Groninger Museum, Groninger, 2002; Museum Kunst Palast, Düsseldorf and *The Rape of Creativity*, Modern Art Oxford, both 2003; *Insult to Injury*, Kunstsammlungen der Veste, Coburg, 2004 and *Explaining Christians to Dinosaurs*, Kunsthaus Bregenz in 2005.

Group exhibitions include: *Brilliant!: New Art from London*, Walker Art Center, Minneapolis and *General Release: Young British Artists*, Scuola di San Pasquale, Venice, both 1995; *Life/Live*, Musée d'Art Moderne de la Ville de Paris, 1996; *Sensation*, Royal Academy of Art, London, 1997—later touring to Hamburger Bahnhof, Berlin and Brooklyn Museum, New York; *Wounds: Between Democracy and Redemption in Contemporary Art*, Moderna Museet, Stockholm, 1998; *Apocalypse: Beauty and Horror in Contemporary Art*, Royal Academy of Arts, London, 2000; *Francisco Goya and Jake and Dinos Chapman: The Disasters of War*, Musée des Beaux-Arts de Montréal, 2001; *Mars. Art and War*, Neue Galerie Graz am Landesmuseum Joanneum, Graz, 2003 and *Deliver us from Evil*, Matthew Marks Gallery, New York, 2004.

Tacita Dean
Born 1965

Dean was born in Canterbury and studied at Falmouth School of Art 1985–1988 before entering the Slade School of Fine Art, London, 1990–1992. She was nominated for the Turner Prize, Tate Gallery, London in 1998, and awarded the Aachen Kunstpreis in 2002. She has also been shortlisted for the Preis der Nationalgalerie für Junge Kunst at the Hamburger Bahnhof, Berlin. Dean undertook a residency at the DAAD International Artists' Programme, Berlin in 2000–2001. She lives and works in Berlin.

Dean's first solo exhibition, *The Martyrdom of St. Agatha and Other Stories*, was held jointly at Galerija Skuc, Ljubljana and Umetnostna Galerija, Maribor, Slovenia in 1994. She has had many important solo shows since, including: Galerie La Box, Ecole Nationale de Beaux Arts, Bourges, 1995; *Foley Artist* at the Tate Gallery in 1996; Witte de With Center for Contemporary Art, Rotterdam and The Drawing Center, New York, 1997; ICA Philadelphia, 1998; Sala Montcada de la Fundació "la Caixa," Barcelona, 2000; Tate Britain, 2001; Museo Serralves, Portugal, 2002; ARC, Musee d'Art Moderne de la Ville de Paris, 2003 and De Pont Foundation, Tilburg, the Netherlands, 2004.

Dean's prolific group showings include: *Mise en Scene*, Institute of Contemporary Arts, London, 1994; *The British Art Show 4*, London and tour 1995; *State of Mind*, Centrum Beeldende Kunst, Rotterdam, 1996; *At One Remove*, Henry Moore Institute, Leeds, 1997; *Wounds: Between Democracy and Redemption in Contemporary Art*, Moderna Museet, Stockholm, 1998; *New Visions of the Sea*, National Maritime Museum, London, 1999; *Media City* Seoul 2000, Seoul Metropolitan Museum and *Artifice*, Deste Foundation, Athens, Sammlung des Kunstmuseums Winterthur, all 2000; *Directions*, Hirshhorn Museum, Washington, DC, 2001; *Subreel*, Galleries Contemporaines de Musées de Marseilles, 2002; *Stazione Utopia and Ritardi e Rivoluzioni*, Venice Biennale, 2003 and *Remind...*, Kunsthaus Bregenz, 2004.

Dean initially trained as a painter and now works in a variety of media. She is perhaps best known for her 16mm short films in which the specific qualities inherent in filmmaking are given central importance. Dean's films are often haunted by abandoned architectural relics which, at their time of construction, promised much in design and purpose. These lost buildings often seem to embody outmoded or excluded systems of belief. Dean also unearths fragments of lost lives, characters and narratives from archival sources, re-constructing individual stories in cinematic short narratives which exist somewhere in the transient space between fact and fiction.

In their formal qualities, the completed films often reference many other art forms, especially painting. Dean also works with video, drawing, photography and objects, as well as sound. Her practice occupies elusive territory somewhere between the real and the imagined. The resulting work is pervaded by a sense of elusiveness, and a search for something which actively exists as much in the imagination as anywhere else. Dean lives and works in London and is represented in numerous international collections.

Tracey Emin
Born 1963

Emin was born in London, soon after her family relocated to the seaside town of Margate where she was raised. Emin studied at Maidstone College of Art, 1986–1989 before completing her Masters at the Royal College of Art, London 1989–1991. She was awarded the International Award, Baden-Baden Video Art Prize, Südwest Bank, Stuttgart in 1997, and was nominated for the Turner Prize, Tate Gallery, London in 1999. Tracey Emin lives and works in London.

After destroying all of her early Munch and Schiele-influenced paintings when she suffered what she has described as her "emotional suicide" following an abortion,

Emin's first solo exhibition at White Cube in 1993 *My Major Retrospective*—titled through Emin's belief it would be the last show she would ever have, included a display of personal memorabilia and photographs of all her destroyed paintings in a disarmingly frank exploration of her own life. Many international solo exhibitions have followed, including: *It's not me that's crying, it's my soul*, Galerie Mot & Van den Boogaard, Brussels, 1996; *I Need Art Like I Need God*, South London Gallery, 1997; Galerie Phillipe Rizzo, Paris and Galerie Gebauer, Berlin, both 1998; *Every Part of Me's Bleeding*, Lehmann Maupin, New York, 1999; Haus der Kunst, München, *This is Another Place*, Modern Art Oxford and *Ten Years*, Stedelijk Museum, Amsterdam, all 2002; *Monoprints*, Museo de Bellas Artes, Santiago, 2004 and *Death Mask*, National Portrait Gallery, London, 2005.

Group exhibitions include: *Minky Manky*, South London Gallery, London and *Brilliant!: New Art from London*, Walker Art Center, Minneapolis, both 1995; *Full House*, Kunstmuseum Wolfsburg and *Life/Live*, Musée d'Art Moderne de la Ville de Paris, both 1996; *Sensation*, Royal Academy of Art, London, 1997—later touring to Hamburger Bahnhof, Berlin and Brooklyn Museum, New York; *Loose Threads*, Serpentine Gallery, London and La Biennale de Montreal, Centre International D'Art Contemporain de Montréal, both 1998; *Hundstage*, Gesellschaft für Aktuelle Kunst, Bremen, 1999; *The British Art Show 5*, The Scottish National Gallery of Modern Art and tour, 2000; *Televisions*, Kunsthalle Wien and Century City, Tate Modern, London, both 2001; *Public Affairs*, Kunsthaus Zurich, 2002; *Micro/Macro*, Budapest Kunsthalle and *Happiness: A Survival Guide for Art and Life*, Mori Art Museum,

Tokyo, both 2003. Recent group exhibitions include: *Secrets of the '90s*, Museum voor Moderne Kunst, Arnhem and the 1st International Contemporary Art Biennial of Seville, both 2004; *Edvard Munch and the Art of Today*, Museum am Ostwall, Dortmund and *Vivisección*. *Dibujo Contemporáneo*, Museo de Arte Carrillo Gil, Mexico City, both 2005.

Emin's art is one of disclosure. She uses her life events as the raw materials in works incorporating a broad range of practices, from story telling, drawing, filmmaking, installation, painting and neon to photography, appliqué and sculpture.

Emin exposes herself, her hopes, fears, humiliations, desires, regrets in a direct and open manner. Often tragic and frequently humorous, it is as if by telling her story and weaving it into the fiction of her art, she purges herself of her past. Often employing metaphoric ready-made everyday materials in her work, such as the infamous tent in *Everyone I Have Ever Slept With 1963-1995*, Emin's confessions are genuinely inclusive, often striking a chord of recognition in us all.

Douglas Gordon
Born 1966

Gordon was born in Glasgow. He studied at Glasgow School of Art 1984–1988 and the Slade School of Art, University of London 1988–1990. He has won numerous awards including the Turner Prize at the Tate Gallery in 1996; the Central Kunstpreis, Kunstverein Cologne, 1997; the Premio 2000 at the Venice Biennale in 1997, and the Hugo Boss Prize at the Solomon R. Guggenheim Museum, New York in 1998. He participated in the DAAD Artists Programme, Hannover and Berlin 1997–1998. He lives and works in New York and Glasgow.

Gordon works in a varied selection of media, but most significantly epitomizes a new fluidity between video and film in contemporary art. Using both original and appropriated footage, often presented as large video installations, his work explores major themes, frequently as coexisting opposites within representations of the body, and often mapped out on the canvas of the artist himself; good and evil, temptation and repulsion, memory and loss, guilt and innocence, life and death. Gordon's work seeks to make the viewer complicit in these confessional spectacles, invoking conflicting emotions to convey a perception of the human condition as mutable and contradictory.

For his first solo exhibition, at Tramway, Glasgow in 1993, Gordon made what is now regarded as a seminal work: *24 Hour Psycho*. He has said of the work: "The viewer is pulled back into the past in remembering the original, then pushed into the future in anticipation of a preconceived narrative that will never appear fast enough." The first time in which he used existing film footage, Gordon slowed down the famous Alfred Hitchcock film to a few frames per minute, resulting in a full day being required to view the entire film from start to finish.

Gordon has since exhibited extensively worldwide. He has had major solo exhibitions at the Musée d'Art Moderne de la Ville de Paris in 1993, and again in 2000. Further solo exhibitions include: Centre Georges Pompidou, Paris, 1995; Kunstverein Hannover, 1998; Centro Cultural de Belem, Lisbon, 1999; Museu de Arte Contemporanea, Porto, 2001; Hayward Gallery, London, Vancouver Art Gallery, 2002; Van Abbemuseum, Eindhoven and Hirshhorn Museum, Washington, DC, both 2004. Gordon has participated in

numerous group exhibitions including: *General Release: Young British Artists*, Scuola di San Pasquale, Venice, 1995; *Spellbound: Art and Film*, Hayward Gallery, London, 1996; *Wounds: Between Democracy and Redemption in Contemporary Art*, Moderna Museet, Stockholm, 1998; *Stan Douglas & Douglas Gordon: Double Vision*, Dia Art Foundation, New York, 1999; *Intelligence: New British Art*, Tate Britain, London and *Rewind to the Future*, Neuer Berliner Kunstverein, both 2000; *Hollywood is a Verb*, Gagosian Gallery, London and *New: Recent Acquisitions of Contemporary British Art*, Scottish National Gallery of Modern Art, Edinburgh, both 2002; *Dreams and Conflicts: The Dictatorship of the Viewer*, Venice Biennale and *Picturing The Artist*, MCA Chicago, both 2003; *Figures de l'acteur*, Galerie Nationale de Jeu de Paume, Paris and *Point of View*, UCLA Hammer Museum, Los Angeles, both 2004; *What's New Pussycat?*, Museum für Moderne Kunst, Frankfurt, 2005.

Sarah Lucas
Born 1962

Lucas was born in London. She studied at the Working Men's College, London, 1982–1983, the London College of Printmaking from 1983–1984 and at Goldsmith's College, University of London 1984–1987. Lucas exhibited in the Venice Biennale in 2003. She lives and works in London.

Lucas' first significant solo exhibition, *Penis Nailed to a Board*, was held at City Racing, London in 1992. For a six-month period during 1993, Lucas staged what was in effect a two-person extended exhibition when she took over an old London shop space at 103 Bethnal Green Road with her artist friend Tracey Emin. The pair exhibited and sold handmade

artworks encapsulating a sneering punk ethic: T-shirts with hand painted slogans, glass ashtrays with a photocopied portrait of Damien Hirst glued in the base and mobiles made from coat hangers. The shop became a vibrant meeting and social space for other artists until the lease ran out, the pair destroying all their remaining stock once the space closed.

Further solo exhibitions include: *Got a Salmon on (Prawn)*, Anthony d'Offay Gallery, London and *Where's My Moss*, White Cube, London, both 1994; *Supersensible*, Barbara Gladstone Gallery, New York, 1995; Museum Boymans van Beuningen, Rotterdam and Portikus, Frankfurt, both 1996; *Bunny Gets Snookered*, Sadie Coles HQ, London and *Car Park*, Ludwig Museum, Cologne, both 1997; *The Old In Out*, Barbara Gladstone Gallery, New York, 1998; *Beautiness*, Contemporary Fine Arts, Berlin, 1999; *The Fag Show*, Sadie Coles HQ, London, 2000; *Charlie George*, Contemporary Fine Arts, Berlin, 2002 and *Temple of Bacchus* (with Colin Lowe and Roddy Thompson), Milton Keynes Gallery, 2003.

Group exhibitions include: Showroom, London, 1986; *Freeze*, Surrey Docks, London, 1988; *East Country Yard Show*, Surrey Docks, London, 1990; Karsten Schubert Gallery, London, 1992; *Young British Artists II*, Saatchi Collection, London, 1993; *Brilliant!: New Art from London*, Walker Art Center, Minneapolis and *Minky Manky*, South London Gallery, both 1995; *Life/Live*, Musée d'Art Moderne de la Ville de Paris, 1996; *Sensation*, Royal Academy of Art, London, 1997—later touring to Hamburger Bahnhof, Berlin and Brooklyn Museum, New York; *Real/Life*, Tochigi Prefectural Museum of Fine Arts, Utsunomiya, Japan, 1998; *Intelligence: New British Art*, Tate Gallery, London and *The British Art Show 5*, The Scottish National Gallery of Modern Art and tour, both 2000; *Century City: Art and*

Culture in the Modern Metropolis, Tate Modern, London and *City Racing 1988-1998: A Partial Account*, ICA, London, both 2001; *Art Crazy Nation*, Milton Keynes Gallery, 2002 and *In-a-Gadda-da-Vida*, Tate Britain, 2004.

Lucas first came to prominence with her large-scale collages consisting of greatly enlarged photocopies and cuttings from British tabloid newspaper articles. In these works, she combined "page-three" pin-up girls with grotesque headlines of sensational journalism. Lucas also integrated the self portrait into many collages as the series developed, the issues surrounding portraiture and gender readings eventually becoming the main concern in her practice.

Lucas photographs herself in assumed masculine poses: seated on a staircase in denim and Doctor Martin boots with her legs spread; slouching against a wall wearing a man's leather jacket, aviator shades and hobnail boots, or eating a banana with a studied attitude. Items of food or everyday objects are arranged as metaphoric still lives, the objects infused with sexual connotations in her ongoing body of sculptural work.

Cornelia Parker
Born 1956

Parker was born in Cheshire, UK, studying fine art at Wolverhampton Polytechnic 1975–1978 before enrolling at Reading University, 1980–1982. She was made a Senior Fellow in Fine Art at Cardiff University from 1992–1995, and was nominated for the Turner Prize at the Tate Gallery, London in 1997. Parker is represented in numerous international public and private collections. She lives and works in London.

Her first solo exhibition was staged at Stoke City Art Gallery

and Museum in 1980. Parker has had a prolific international solo career since, with shows including: Ikon Gallery, Birmingham in 1988; Chisenhale Gallery, London in 1991; Galerie Eigen & Art, Leipzig and Vitrine Hortense Stael, Paris in 1992. In 1995 Parker staged perhaps her best know work *The Maybe*, with the actress Tilda Swinton asleep in a glass vitrine at the Serpentine Gallery, London. Further solo exhibitions include Deitch Projects, New York, 1998; ICA Philadelphia, Aspen Museum of Art, Colorado, both 2000; Galleria Civica d'Arte Moderna e Contemporanea, Turin, 2001; Frith Street Gallery, London in 2002 and Galeria Carles Tache, Barcelona in 2004.

Group exhibitions include: *New British Sculpture*, Air Gallery, London, 1986; *Sarajevo 2000*, Museum Moderne Kunst Stiftung Ludwig, Wien and *Thinking Aloud*, Kettle's Yard, Cambridge with subsequent tour, both 1998; *Documents and Lies*, Optica, Montréal, 1999; *British Art Part I*, Diehl Vorderwuelbecke, Berlin and Between China and a Hard Place, Tate Modern, London, both 2000. Further group exhibitions include 2000: *The end of the century. The seeds of the future*, Commune di Milano, Italy in 2001; *Life is Beautiful*, Laing Art Gallery, Newcastle, 2002; *Days Like These: Tate Triennale*, Tate Britain, London and *Doublures*, Musée national des beaux-arts du Québec, both 2003; City Art Gallery, Prague, 2004.

For a number of years now, Parker's practice has been concerned with formalizing the things in life which are usually perceived as beyond our physical control. In containing and cataloguing volatile, unpredictable phenomena, she introduces a disquieting air of stillness and contemplation, of "being caught in the calm eye of the storm" to otherwise turbulent experiences.

Parker is fascinated with real processes which mimic the cartoon fiction of violent death; filled with leaky holes from lead shot, crushed pancake flat by a steamroller, a puff of dust ending a deep chasm cliff-fall, or the fracturing violence of an explosion. Through these subjects combined with a combination of visual and verbal allusions, her work triggers cultural metaphors and personal associations which allow the viewer to witness the transformation of the most ordinary objects into something compelling and extraordinary.

Sam Taylor-Wood
Born 1967

Taylor-Wood was born in London and studied at Goldsmith's College, University of London 1987–1990. She was awarded the Illy Café Prize for Most Promising Young Artist during the Venice Biennale, 1997. She was nominated for the Turner Prize, Tate Gallery, London, in 1998. Her first solo exhibition, *Killing Time*, was held at the Showroom, London in 1994 and the Hayward Gallery, London hosted a major survey of Taylor-Wood's work in 2002 followed by an extensive exhibition of her work at the Musée d'Art Contemporain de Montréal in the same year. Taylor-Wood lives and works in London.

Further solo exhibitions include: White Cube, London, 1995; Sala Montcada de la Fundació "la Caixa," Barcelona and Kunsthalle Zurich, both 1997; Louisiana Museum of Modern Art, and Prada Foundation, Milan, both 1998; Hirshhorn Museum, Washington, DC, 1999; Matthew Marks Gallery, New York and Museo Nacional Centro de Arte Reina Sofia, Madrid, both 2000; Kunsthalle Wien, 2001; Stedelijk Museum, Amsterdam, 2002; The State Russian Museum, St. Petersburg, 2004 and Galleria Lorcan O'Neill, Rome, 2005.

Group exhibitions include: *General Release: Young British Artists*, Scuola di San Pasquale, Venice and *Brilliant!: New Art from London*, Walker Art Center, Minneapolis, both 1995; *Life/Live*, Musée d'Art Moderne de la Ville de Paris and *Manifesta 1*, Museum Boymans van Beuningen, Rotterdam, both 1996; *Sensation*, Royal Academy of Art, London, 1997—later touring to Hamburger Bahnhof, Berlin and Brooklyn Museum, New York; *Real/Life*, Tochigi Prefectural Museum of Fine Arts, Utsunomiya, Japan, 1998; *Intelligence: New British Art*, Tate Gallery, London and *The British Art Show 5*, The Scottish National Gallery of Modern Art and tour, both 2000; *True Fictions: Inszenierte Fotokunst der 1990er Jahre*, Ludwig Forum für Internationale Kunst, Aachen, 2002; *Process... Encounters in Live Situations/ Shifting Spaces*, Kiasma, Helsinki, 2003; *Between Above and Below*, Center for Curatorial Studies, Bard College, New York, 2004; *Between Art and Life*, San Francisco Museum of Modern Art, 2005.

Taylor-Wood uses photography and film to concentrate on fluctuating moments in everyday life, the explosive tension of momentary stasis, a split second after which an enigmatic situation may change and alter irrevocably. In 1995 she began a series of photographs entitled *Five Revolutionary Seconds*. These panoramic "audio-photographs" were taken with a camera which rotates 360 degrees over five seconds, photographing the space around as it turned. Isolated characters in filmic scenarios populate these frieze-like elongated images, whilst a suggested narrative is provided by the accompanying sound track recorded as the photograph was taken.

Lately, Taylor-Wood's work has explored the boundaries between the sacred and profane, fusing quasi-religious imagery informed by Renaissance and Baroque painting with the secular, contemporary urban landscape she inhabits in a dissection of the modern psyche and the place of the individual within a given social group.

Rebecca Warren

Born 1965

Warren was born in London and attended Goldsmith's College, University of London 1989–1992 before completing her Masters at Chelsea School of Art, London 1992–1993. She was Artist in Residence at Ruskin School, Oxford University 1993–1994 and has work in many public and private collections, including the Saatchi Collection, London. Warren lives and works in London.

Referencing the work of such varied artists as Auguste Rodin, Umberto Boccioni, Edgar Degas and Robert Crumb, Warren uses unfired clay as the basic material for her sculptures. From this raw substance, she fashions awkward, sexually expressive, amorphous masses that suggest barely discernable intertwined forms; protruding limbs and members, bodies writhing in agony or locked in ecstasy.

The organic nature of the sculpture and the sense of tactility is often emphasized by the peculiar lustre Warren applies to the unfired clay. The wickedness of the flesh is a common subject in allegorical painting in particular, metaphorically portrayed in bloody splayed animal carcasses, and historical art debate often alludes to the erotic overtones of phallic forms. Warren explores such ambiguities of meaning

using simple techniques to construct a complex argument for the potential of form.

Warren's first significant solo exhibition *I Have Every Vice in the World*, was held at the 303 Gallery, New York in 1993. She has continued to exhibit widely since, with solo exhibitions including: *Manliness without Ostentation*, The Agency, London, 1995; *The Agony and the Ecstasy*, Maureen Paley, London, 2000; *Fleischvator*, Modern Art, London, 2002; Donald Young Gallery, Chicago, *SHE*, Maureen Paley, London, both 2003 and *Dark Passage*, Kunsthalle Zürich, 2004.

Selected group exhibitions: *Destroy All Monsters*, The Tannery, London, 1994; *Cocaine Orgasm*, BANK, London, *Model Home*, PS1, New York and *Disneyland After Dark: La Ronde*, Kunstmuseum, Uppsala, all 1995; *Light*, Richard Salmon, London, 1996; *Material Culture*, Hayward Gallery, London, 1997; BANK, ICA, London and *The Kindness of Strangers*, W139 Gallery, Amsterdam, both 1998; *Limitless*, Galerie Krinzinger, Vienna and *Day of the Donkey Day*, Transmission Gallery, Glasgow, both 1999; *New Labour*, Saatchi Gallery, London and *Tattoo Show*, Modern Art, London, both 2001; *The Galleries Show*, Royal Academy of Art, London, 2002; *Rachel Harrison, Hirsch Perlman, Dieter Roth, Jack Smith, Rebecca Warren*, Matthew Marks Gallery, New York and *Still Life*, Museo de Arte Carrillo Gil, Mexico City, both 2003.

Gillian Wearing

Born 1963

Wearing was born in Birmingham, and attended Chelsea School of Art from 1985–1987 before gaining her Bachelor of Arts at Goldsmith's College, University of London from 1987–1990. She won the BT Young Contemporaries

prize in 1993, and was an award winner at the Oberhausen Short Film Festival in 1998. Wearing won the Turner Prize, Tate Gallery, London in 1997. She lives and works in London.

Wearing's work demonstrates a complex understanding of the alternately comic and tragic experience of everyday life. She uses the techniques of documentary photography, film and television to frame the concerns, words and actions of ordinary people, often in everyday situations slightly and subtly displaced in context. This repositioning creates an uneasy, voyeuristic sense in the viewer, forcing the audience to question the relationship with their own preconceptions, alongside the image Wearing neutrally presents.

These ongoing concerns were apparent in Wearing's first notable solo exhibition at City Racing, London in 1993. Many have followed, including: Maureen Paley, London, 1994; *City Projects: Prague, Part II*, British Council Gallery, Prague, 1996; Kunsthaus Zürich and Jay Gorney Modern Art, New York, both 1997; Centre d'Art Contemporain, Geneva, 1998; De Vleeshal, Middleburg and Galerie Anne de Villepoix, Paris, both 1999; Regen Projects, Los Angeles and Serpentine Gallery, London, both 2000; Fundación "la Caixa," Madrid, Musée d'Art Moderne de la Ville de Paris and Kunstverein München, all 2001; Vancouver Art Gallery and MCA Chicago, both 2002; Maureen Paley, London, 2003 and Regen Projects, Los Angeles in 2004.

Group exhibitions include: *Clove I*, The Clove Building, London, 1991; *Instruction*, Marconi Gallery, Milan, 1992; *Mandy loves Declan 100%*, Mark Boote Gallery, New York and *Okay Behaviour*, 303 Gallery, New York, both 1993; *Le Shuttle*, Künstlerhaus Bethanien, Berlin, 1994; *Brilliant!: New Art from London*, Walker Art Center,

Minneapolis and *Campo*, Venice Biennale, both 1995; *Full House: Young British Art*, Kunstmuseum Wolfsburg, I.D., Stedelijk Van Abbemuseum, Eindhoven and *Life/Live*, Musée d'Art Moderne de la Ville de Paris, all 1996; *Sensation*, Royal Academy of Art, London, later touring to Hamburger Bahnhof, Berlin and Brooklyn Museum, New York and *Projects*, Irish Museum of Modern Art, Dublin, both 1997; *Fast Forward Body Check*, Kunstverein, Hamburg and *In Visible Light*, Moderna Museet, Stockholm, both 1998; *Garden of Eros*, Centre Cultural Tecla Sala, Barcelona and the Sixth International Istanbul Biennial, both 1999; Biennale of Sydney, Museum of Contemporary Art, Sydney and *Intelligence: New British Art*, Tate Gallery, London, both 2000; *Century City*, Tate Modern and *Confidence pour confidence*, Casino Luxembourg, both 2001; *Mirror Image*, UCLA Hammer Museum, Los Angeles and *I Promise, it's Political*, Museum Ludwig, Cologne, both 2002; *Independence*, South London Gallery, London, 2003; *Artists' Favourites, Act II*, ICA, London and *Monument to Now*, DESTE Foundation Centre for Contemporary Art, Athens, both 2004 and *Emotion Pictures*, Museum voor Hedendaagse Kunst, Antwerp, 2005.

Cathy Wilkes
Born 1966

Wilkes was born in Belfast, Northern Ireland and studied at Glasgow School of Art 1985–1988 before completing her Masters at University of Ulster, 1991–1992. She was selected for the first Beck's Futures Prize exhibition at the ICA, London in 2000 and represent Scotlanded at the

Venice Biennale in 2005. Wilkes lives and works in Glasgow.

Wilkes creates disquieting abstract sculpture and installation, fusing eroding domestic detritus with tangled clusters of signs by intervening on the surface of an object with a small patch of colour, a drawing or text. Wilkes' interventions sometimes echo the physicality of these worn props, and more often than not simulate the process of damage related to time, the ghost of the fading human presence.

There is a sense of stumbling upon a private naturalistic stage, where fragments of rooms with real furniture provide the settings for domestic and familial conflict, and of shutting the viewer out even as Wilkes invites them in. This sense of intrusion or voyeurism is further emphasized by demanding that the viewer invade the work itself to look at it.

Wilkes' first significant solo exhibition was at the Third Eye Centre, Glasgow in 1989. She has exhibited widely since, including: Tanya Utca, Csongrad, Hungary, 1990; Transmission Gallery, Glasgow, 1991; Galerie CAOC, Berlin, 1994; Art Connexion, Lille, 1996; *Mr. So and So*, Galerie Giti Nourbakhsch, Berlin and Cubitt Gallery, London, both 2001; Inverleith House, Edinburgh and Migros Museum, Zurich, both 2002; *She Good*, Kabinett für aktuelle Kunst, Bremerhaven, 2003; Douglas Hyde Gallery, Dublin, Switchspace, Glasgow and Raucci Santamaria Galleria, Naples, all 2004.

Selected group exhibitions include: *World of Ponce*, Toby Webster, Glasgow and *Loaded*, Ikon Gallery, Birmingham, both 1996; Lovecraft, CCA, Glasgow, 1997; *Add Night to Night*, The Showroom, London, 1998; *Seven Scottish Artists*, Grant Selwyn Fine Art, Los Angeles, 2000; *Here and Now*, Dundee Contemporary Arts;

Psycho-Bobble, Raucci Santamaria Galleria, Naples and *Circles 4 One for One*, ZKM, Karlsruhe, all 2001; *Happy Outsiders*, Zacheta Gallery, Warsaw and The Gwanju Biennial, South Korea, both 2002; *Independence*, South London Gallery and *Plunder: Culture as Material*, DCA, Dundee, both 2003; *L'Air Du Temps*, Migros Museum, Zurich, and Stedelijk Museum voor Actuele Kunst, Gent, all 2004.

Carey Young
Born 1970

Young was born in Lusaka, Zambia. She studied at the University of Brighton 1989–1992 and Royal College of Art, London 1995–1997. She held a Research Fellowship with the Henry Moore Institute, 2002–2003, and participated in the IASPIS Fellowship, Stockholm in 2004. Young was nominated for the Beck's Futures Prize, ICA, London, in 2003. Her work is held in the public collections of the Arts Council England and the Centre Pompidou. She lives and works in London.

Young's work has become recognized internationally for its investigation into the increasing incorporation of personal and public domains into the commercial realm. For the contemporary artist, relationships with the corporate and academic worlds are complex and often contradictory. Far from the myth of the romantic outsider, most artists now depend on corporate and institutional support, much as they did on aristocracy or the church in the past.

Young immerses herself in the power structures of these academic and corporate organizations, engaging and expanding, often as a temporary office employee, notions of what art might be in her working

process. Using the office language of employee training programs, PowerPoint presentations, whiteboard discussions, employee questionnaires and distribution list emails, Young introduces ideas and concerns familiar in art or academic practice into unfamiliar territory. Unlike the first generation conceptual artists, whose tactics developed in tandem with, and were often absorbed by, the mass media, Young does not operate oppositionally. Instead, by highlighting the codependence of individuals and organizations, she explores the moral ambiguities and strategic identifications demanded in our ideologically impure times.

Carey Young's first significant solo exhibition was *Nothing Ventured* staged at Fig.1, a temporary commercial gallery project near London's Oxford Street, 2000. Many have followed, including; *My Megastore: Site specific works at Virgin Megastore*, London, 2001; *Business as Usual*, John Hansard Gallery, Southampton and tour, *Viral Marketing*, Kunstverein München, both 2002; *IBID Projects*, Vilnius, 2003; Index Contemporary Art Centre, Stockholm and *Disclaimer*, Henry Moore Institute, Leeds, both 2004; *IBID Projects*, London and Trafo Gallery, Budapest, both 2005.

Selected group exhibitions; *Stream*, Plummet, London, 1995; *Zones of Disturbance*, Marieninstitut, Graz, 1997; *CRASH!*, ICA, London, 1999; *Media Art 2000*, Metropolitan Museum of Modern Art, Seoul and *Continuum 001*, CCA, Glasgow, both 2000; *Ausgetraumt*, Secession, Vienna, *The Communications Department*, Anthony Wilkinson, London and *Nothing*, Northern Gallery of Contemporary Art, Sunderland, all 2001; *Exchange and Transform*, Kunstverein Munich, 2002; *Dust to Dusk*, Charlottenborg Palace, Copenhagen, *World Question Centre (Reloaded)*, Basis voor Actuele Kunst, Utrecht

and *Electric Earth*, State Russian Museum, St. Petersburg and tour, all 2003; *Cycle Tracks* will abound in Utopia, CCA, Melbourne and *Trailer*, Man in the Holocene, London, both 2004; *What Business Are You In?*, Contemporary Art Center, Atlanta, *Trade Show*, MoCA, North Adams, Massachusetts and *Revolution is on Hold*, Isola Dell'Arte, Milan, all 2005.

All dimensions are in centimetres, height precedes width, precedes depth

Fiona Banner
SPREAD 1
2001
 screen print on aluminum
 2 panels
 250 × 108
 Courtesy the Artist and
 Frith Street Gallery, London

Martin Boyce
Brushing Against Strange Weeds
(Edges and No Edges)
2004
 enamel paint on aluminum
 225 × 150
 Courtesy the Artist and
 The Modern Institute, Glasgow

Everything Goes Away
In The End
2004
 plywood, zinc plated steel,
 lacquered MDF, powder
 coated steel, wire, altered
 series 7 Jacobsen chairs
 141 × 120 × 66
 Private Collection
 Courtesy the Artist and
 The Modern Institute, Glasgow
We Fade in the Sun
and Shine in the Lamplight
(This Place Fills Us)
2004
 enamel paint on aluminum
 225 × 150
 Courtesy the Artist and
 The Modern Institute, Glasgow

Jake and Dinos Chapman
My Giant Colouring Book
2004
 21 etchings on paper
 50.8 × 40.6 each
 Collection of the British Council

Tacita Dean
Mario Merz
2002
 16mm colour film, optical sound
 8:03 min. (looped)
 front projected;
 variable dimensions
 Courtesy the Artist and
 Frith Street Gallery, London

Tracey Emin
I've Got It All
2000
 inkjet print
 121.9 × 91.4
 Courtesy the Artist and
 Jay Jopling/White Cube, London
Something's Wrong
2002
 appliqué blanket
 with embroidery
 200 × 154
 Collection of the British Council
Top Spot
2004
 colour film on DVD
 63 min.
 Courtesy the Artist, United

Artists North America and
Jay Jopling/White Cube, London

Douglas Gordon
The Left Hand Doesn't Care
What the Right Hand Isn't Doing
2004
 single channel video,
 infinite loop
 dimensions variable
 Courtesy the Artist and
 Gagosian Gallery, Beverly Hills
The Right Hand Doesn't Care
What the Left Hand Isn't Doing
2004
 single channel video,
 infinite loop
 dimensions variable
 Courtesy the Artist and
 Gagosian Gallery, Beverly Hills
The Left Hand Can't See That the Right
Hand is Blind
2004
 single channel video,
 infinite loop
 dimensions variable
 Courtesy the Artist and
 Gagosian Gallery, Beverly Hills

Sarah Lucas
Bunny Gets Snookered #4
1997
 tan tights, black stockings,
 wood and vinyl chair,
 kapok, wire
 95 × 64 × 90
 Private Collection
 Courtesy the Artist and
 Sadie Coles HQ, London
(from *Self Portraits 1990–1998*,
1999 portfolio)
Eating a Banana
1990
 iris print on Somerset
 Velvet paper
 80 × 60
 Courtesy the Artist and
 Sadie Coles HQ, London
Divine
1991
 iris print on Somerset
 Velvet paper
 80 × 60
 Courtesy the Artist and
 Sadie Coles HQ, London

Works in the Exhibition

Self Portrait with Mug of Tea
1993
 iris print on Somerset
 Velvet paper
 80 × 60
 Courtesy the Artist and
 Sadie Coles HQ, London
Self Portrait with Knickers
1994
 iris print on Somerset
 Velvet paper
 80 × 60
 Courtesy the Artist and
 Sadie Coles HQ, London
Fighting Fire With Fire
1996
 iris print on Somerset
 Velvet paper
 80 × 60
 Courtesy the Artist and
 Sadie Coles HQ, London
Human Toilet II
1996
 iris print on Somerset
 Velvet paper
 80 × 60
 Courtesy the Artist and
 Sadie Coles HQ, London
Self Portrait with Fried Eggs
1996
 iris print on Somerset
 Velvet paper
 80 × 60
 Courtesy the Artist and
 Sadie Coles HQ, London
Got a Salmon On #3
1997
 iris print on Somerset
 Velvet paper
 80 × 60
 Courtesy the Artist and
 Sadie Coles HQ, London
Self Portrait with Skull
1997
 iris print on Somerset
 Velvet paper
 80 × 60
 Courtesy the Artist and
 Sadie Coles HQ, London
Human Toilet Revisited
1998
 iris print on Somerset
 Velvet paper
 80 × 60
 Courtesy the Artist and

Sadie Coles HQ, London
Smoking
1998
 iris print on Somerset
 Velvet paper
 80 × 60
 Courtesy the Artist and
 Sadie Coles HQ, London
Summer
1998
 iris print on Somerset
 Velvet paper
 80 × 60
 Courtesy the Artist and
 Sadie Coles HQ, London

Cornelia Parker
Shared Fate (Oliver)
1998
(With thanks to Madame Tussaud's)
 doll cut by the guillotine
 that beheaded Marie Antoinette
 dimensions variable
 Courtesy the Artist and
 Frith Street Gallery, London
Feather from Freud's Pillow
(from his couch)
1998
(With thanks to the Freud Museum)
 photogram
 63 × 63
 Courtesy the Artist and
 Frith Street Gallery, London
Marks made by Freud, Subconsciously
2000
(With thanks to the Freud Museum)
 macrophotograph of
 the seat of Freud's chair
 63 × 63
 Courtesy the Artist and
 Frith Street Gallery, London

Sam Taylor-Wood
Five Revolutionary Seconds VI
1996
 colour photograph
 on vinyl with audio
 72 × 757
 Collection of the British Council

Rebecca Warren
Head
2004
 bronze
 80 × 60 × 70

Courtesy the Artist and
Maureen Paley, London
Saperstein
2004
 self-firing, painted clay
 37 × 28 × 31
 Private Collection
 Courtesy the Artist and
 Maureen Paley, London
Der Krieg II
2004
 self-firing, painted clay
 45 × 33 × 29
 Private Collection
 Courtesy the Artist
 and Maureen Paley, London

Gillian Wearing
*Homage to the Woman with the
Bandaged face who I saw Yesterday
down the Walworth Road*
1995
 black and white video
 projection with subtitles
 7.00 minutes
 Courtesy the Artist and
 Maureen Paley, London
Dancing in Peckham
1994
 colour video, silent
 25.00 minutes
 Courtesy the Artist and
 Maureen Paley, London

Cathy Wilkes
Untitled
2001
 mattress, tin,
 oil on canvas, wood
 dimensions variable
 Private Collection
 Courtesy the Artist and
 The Modern Institute, Glasgow

Carey Young
I am a Revolutionary
2001
 single channel video,
 colour, sound
 4.05 minutes
 Commissioned by Film & Video
 Umbrella in association with
 John Hansard Gallery,
 Southampton
 Courtesy the Artist

Published in conjunction with the exhibition
Body: New Art from the UK, curated by Bruce
Grenville and Colin Ledwith and jointly organized
by the British Council and the Vancouver Art
Gallery. The exhibition is part of "UK Today:
A New View," a year-long celebration of creative
partnerships between Vancouver and the United
Kingdom, and presented at the Vancouver Art
Gallery from May 28 to September 5, 2005.

Body: New Art from the UK
Exhibition Tour Itinerary

Vancouver Art Gallery
May 28 – September 5, 2005

The Ottawa Art Gallery
November 25, 2005 – February 5, 2006

Oakville Galleries
April 8 – June 4, 2006

Edmonton Art Gallery
June 23 – September 3, 2006

Art Gallery Nova Scotia
October 28, 2006 – January 14, 2007

Editing: Deanna Ferguson
Design: Julian Gosper
Printed and bound in Canada by Hemlock
Printers Ltd., Burnaby, British Columbia

The Vancouver Art Gallery gratefully acknowledges
the support of the City of Vancouver, the Province
of British Columbia through the BC Arts Council
and Gaming Revenues, the Government of Canada
through the Canada Council for the Arts, the
Department of Canadian Heritage Museums
Assistance Program and Cultural Spaces Canada.

Cover image: Sarah Lucas, *Fighting Fire with Fire*,
1996 (from *Self Portraits 1990–1998*, 1999)
Courtesy the Artist and Sadie Coles HQ, London

Library and Archives Canada
Cataloguing in Publication

Body: New Art from the UK /
curated by Bruce Grenville and Colin Ledwith.

Catalogue of an exhibition held at the
Vancouver Art Gallery May 28 – September 11, 2005.
"This exhibition is jointly organized by the
British Arts Council and the Vancouver Art Gallery.
It is part of UK Today: a new view, a year-long
celebration of creative partnerships between
Vancouver and the United Kingdom."

ISBN 1-895442-51-6

1. Art, British--21st century--Exhibitions.
2. Human figure in art.
I. Grenville, Bruce
II. Ledwith, Colin
III. Vancouver Art Gallery
IV. Arts Council England
V. Title: UK today.

N6768.6.B63 2005 709'.41'07
471133 C2005-901945-X

BRITISH COUNCIL UK TODAY A NEW VIEW Vancouver Artgallery